Dogs are our link to paradise.

—MILAN KUNDERA

Love Your DOG Pictures

How to Photograph Your Dog with Any Camera

Jenni Bidner

Watson-Guptill Publications

New York

I would like to thank the following photographers for their contributions to this book: Janet Anagnos, Eric Bean, Greg Friese, Anne Gridley Graves, Heather Houlahan, Shannon Kiley, Ellen Labenski, Patty Rusch, Laura Sanborn, Nancy Thornton, Andrea von Buddenbrock, and Meleda Wegner. I would also like to acknowledge the superb photographic talent of both the U.S. military and FEMA photographers whose images appear in this book.

Editorial Director: Victoria Craven
Senior Development Editor: Alisa Palazzo
Designer: Pooja Bakri, Pooja Bakri design
Production Manager: Hector Campbell

Copyright © 2006 Jenni Bidner

First published in New York in 2006 by
Watson-Guptill Publications
a division of VNU Business Media, Inc.
770 Broadway
New York, NY 10003
www.wgpub.com

Library of Congress Cataloging-in-Publication Data
Bidner, Jenni.
 Love your dog pictures : how to photograph your dog with any camera / Jenni Bidner.
 p. cm.
 Includes index.
 ISBN-13: 978-0-8230-7228-6 (pbk.)
 ISBN-10: 0-8230-7228-2 (pbk.)
 1. Photography of dogs. 2. Dogs--Pictorial works. I. Title.
 TR729.D6B53 2006
 778.9'39772--dc22

 2005034306

Printed in Singapore

1 2 3 4 5 6 7 8 9 / 14 13 12 11 10 09 08 07 06

Until one has loved an animal, a part of one's soul remains unawakened.

— Anatole France

CONTENTS

Introduction

We love our dogs. We cherish our dogs. But most of us can't get consistently great pictures of them. Sometimes this is due to technical issues, and the pictures are blurry, grainy, or too dark or light. Other times, your results just don't look like what you saw. Or perhaps your pictures are generally good, but you want them to be award-winning great.

Whether you're the designated "family photographer" by choice or by default, you have a big job. Not only do you want to document your dog or dogs, but you'll want to show them as part of your family and lifestyle. You'll want to create images for your scrapbooks and walls that stand the test of time.

This book is designed to help you take great pictures of your dog—whether you use an inexpensive point-and-shoot camera or a fancy SLR (single-lens reflex) with interchangeable lenses. Whether you use digital or film, it doesn't matter! Using the tips and techniques included here, you'll see a vast improvement in your photographs.

So take a look at the lovable dogs on these pages. Pretty soon, you'll see how to get similar results with your pooch. You'll find the basics on the more nitty-gritty technical issues, like equipment and exposure techniques, up front, while the images and general topics later on will give you an understanding of what to do. Don't feel compelled to read the book cover to cover in one sitting. You can simply jump around, and find the pictures and tips you need today. However you approach this book, I hope it will help you create images of your dogs that show their true spirit. I hope it will help you love your dog pictures. Enjoy!

Among God's creatures two, the dog and the guitar, have taken all the sizes and all the shapes, in order not to be separated from the man.

—Andrés Segovia

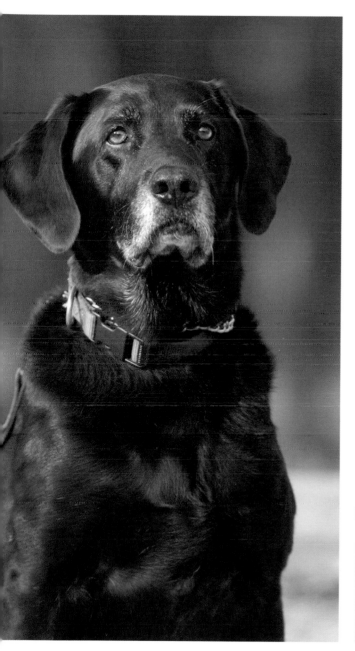

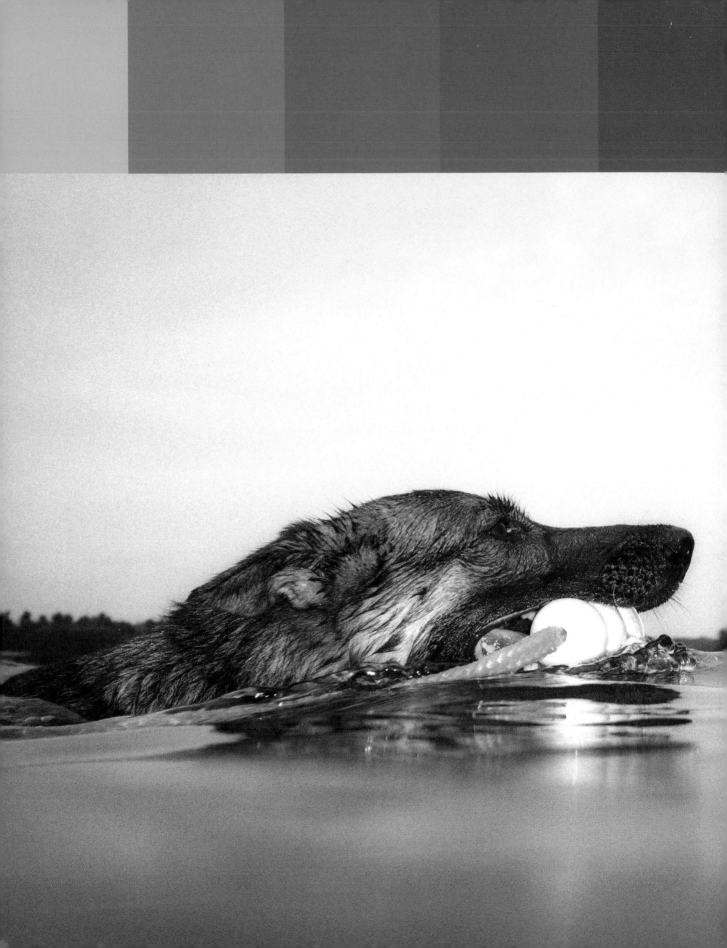

DOG TOYS
Equipment

1

Although it might seem like no fun, getting familiar with the different types of photographic equipment out there—cameras, digital media, films, and lenses—will go a long way toward improving your images. The more comfortable you are with your tools, the more you can do with them—and make them work to your advantage.

Cameras

Understanding your camera's capabilities is a key to taking great pictures of your dog, whether that camera is a $5 disposable one, a fancy digital model, or a professional-level SLR (single-lens-reflex). The first decision that a photographer faces is the type of camera to use. Considerations include point-and-shoot cameras vs. SLRs and film vs. digital.

Point-and-shoot cameras (above) are the most common type of camera. Most have relatively slow autofocusing capability, which is also usually center-weighted (indicated by the one central red box in the image below). Since center-weighted focusing keys in on whatever is in the center of the scene, this can result in misfocused images if your subject is not at the exact same focusing center indicated by the box.

SLR cameras usually have more sophisticated autofocusing capabilities that focus better and faster than point-and-shoot cameras. Many offer multisegment AF (autofocus) sensors or *islands* (indicated by the multiple red boxes, bottom,right). This allows for better autofocusing on moving and off-center subjects. For example, in this picture, the yellow box would represent the sensor that acts as the camera's focusing point for this scene. In addition, a few SLR cameras enable precise manual focusing capabilities.

Point-and-Shoot Cameras

Most cameras (whether film or digital) are point-and-shoots, which tend to be compact and easy to use. Low-end models may be focus-free, meaning they do not automatically focus and require that your subjects be within a certain distance range for good results. Better cameras provide focusing options, a zoom lens, specialized exposure modes, sophisticated flash options, and other features.

By definition, point-and-shoot cameras are a lens-shutter design. As such, they have two lenses—one for viewing the scene and one to take the picture. So unlike with an SLR (single-lens-reflex) camera, with a point-and-shoot, what you see in the viewfinder is *not exactly* what you will see in the final composition. If your finger strays onto the picture-taking lens, you may not see it in the viewfinder, but it will certainly be visible in the print.

With dogs that are at a distance from the camera and with average conditions, the lens-shutter design is not an issue. However, when you want to shoot a subject up close, your photographs could suffer from *parallax error* (see page 30), in which parts of the subject are cut off in the final image.

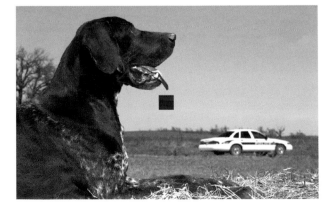

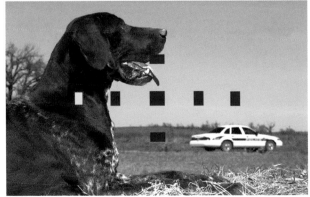

Another problem is that most point-and-shoot cameras have heavily center-weighted autofocus. This means that if your main subject is off center in your composition, the camera will focus on the background, not on the main subject—but you won't see the lack of focus in the viewfinder. You can get around this difficulty by practicing the focus lock technique described on page 12.

Note that there are a few SLR cameras that are so small and easy to use that they seem to be point-and-shoot cameras. But, it is their through-the-lens (TTL) viewing design that separates them from their lens-shutter (point-and-shoot) counterparts.

SLR Cameras

Single-lens-reflex (SLR) cameras tend to be larger than point-and-shoots, have advanced controls and accessories, and offer through-the-lens (TTL) viewing, meaning that what you see in your viewfinder is what the lens sees—and, therefore, what you get in the final image. The advantage is that you see most of the effects of the lens and can verify *in the viewfinder* that the camera is focusing correctly (whether automatically or manually). Advanced photographers will appreciate the depth-of-field preview feature (available on some cameras), which enables you to see how the aperture setting will affect your final pictures (see page 43 for more).

Many SLR cameras also offer sophisticated autofocusing, with multiple sensors to detect and track off-center or moving subjects. In addition to being able to continuously focus on moving subjects, these cameras offer extremely fast shutter speeds (such as 1/8000 sec.) for freezing action.

An often overlooked creative advantage of SLR cameras is the availability of different exposure modes that give you full control over aperture and shutter speed selection. If you choose not to use these various exposure modes, most modern SLRs offer a fully automated Program (P) mode that gives excellent results in general shooting situations.

Plus, interchangeable lenses (see page 24) provide options that are impossible with a point-and-shoot camera. You have a choice of super-wide-angle lenses, telephoto lenses for distant subjects, macro lenses for close-ups, and zoom lenses that encompass part, or all, of that range. Other SLR accessories include powerful accessory flash units, studio-style flash units, remote triggering devices, underwater housings, and more.

Manual-focus and manual-exposure SLRs are popular with photography students both because they're economical and because they require the photographer to "learn" the controls. Low-end autofocusing models are highly automated and enable few manual controls. Top-of-the-line professional models offer both.

SLR cameras are usually thought of as "pro" cameras.

Most SLR cameras can be used with accessories, such as a remote shutter release. This allows the photographer to hide a camera in a remote spot (like the trunk of a car) and trigger the shutter from a distance when the subject (a detection dog) arrives.

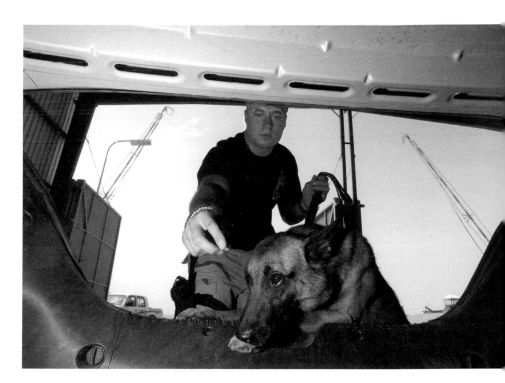

Point-and-Shoot Autofocusing Challenges

As mentioned previously, most point-and-shoot cameras have very center-oriented autofocusing systems. They're designed to focus on whatever is in the center of the frame. This can be a disaster if your subject is off-center even slightly. But if you want to photograph two nearby dogs, or a dog and a few people, what falls in the center of the frame is usually not the subject but rather a gap filled by the background. Since you're looking through a viewfinder that's not coordinated with the lens, you won't know that the focus isn't correct until you get your film back.

To meet this challenge, you need to practice the *focus lock technique*: First, center the subject and push the shutter button halfway down to lock the focus and exposure. Then, while still holding the shutter button in the halfway position, recompose the image. When your image is composed as you want it, completely push the shutter button down and expose the picture.

Photographers who use SLR cameras don't usually have this concern. Their cameras often have more sophisticated focusing systems that usually avoid this problem, and in any case, they can see the missed focus in the viewfinder.

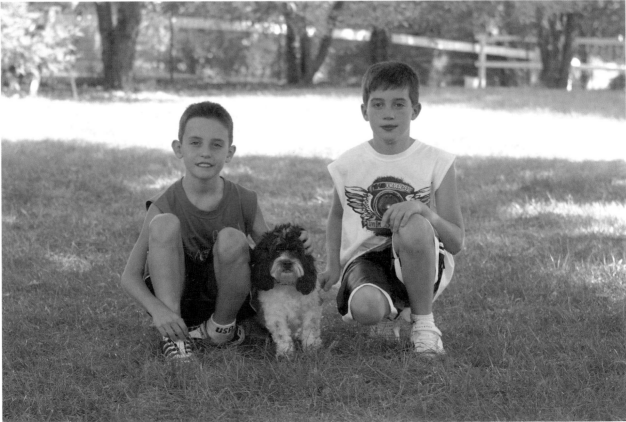

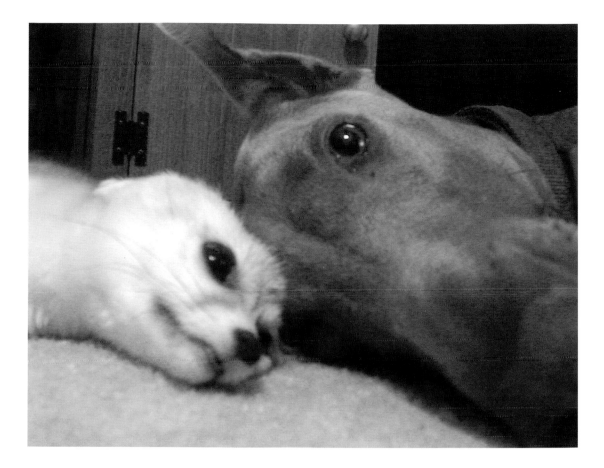

In order to really enjoy a dog, one doesn't merely try to train him to be semihuman. The point of it is to open oneself to the possibility of becoming partly a dog.

— EDWARD HOAGLAND

Minimum Focusing Distance

It's important to learn the minimum focusing distance of your camera or lenses (in the case of an SLR with interchangeable lenses). If you're too close, some point-and-shoot cameras will warn you with a red light in the viewfinder or an audible beep, or they will refuse to take the picture altogether. The through-the-lens (TTL) capability of an SLR camera will let you see this problem in the viewfinder, but with some point-and-shoot film cameras, the first you learn about the problem is when you look at your out-of-focus prints. Additionally, your camera's flash may have trouble illuminating close subjects properly. Check your instruction manual and experiment with this, because extremely close-up pictures can be a lot of fun.

If your camera doesn't warn you about the minimum focusing distance, consider changing your camera strap to a string that is the exact length of the minimum focusing distance. Then, when you're shooting close in to your subject, stretch out this string to determine if you are within range.

PROTECT YOUR CAMERA

Any time you're shooting pictures near water—whether it's water from rain, snow, mist, or splashes—you'll need to protect your camera. Most modern cameras are full of electronics that can be destroyed by water, or even high humidity. Even so-called weather- or water-resistant cameras need to be protected. They can survive a misting, but you don't want to be dunking them in the water.

Some cameras are designed to be used underwater at snorkeling (sixteen-foot or less) or diving (100-foot) depths.

Many dogs love to swim, or at least get wet and muddy. And some of your best pictures may be of this activity. But how do you get great pictures without ruining your camera? Any time you're in the same vicinity of wet dogs, whether they've been swimming or just had a bath, chances are you (and your camera) are going to get wet. It's simply a matter of the "shake factor," and I don't think there's any way to avoid it! You need to either protect your current camera, use a water-resistant camera, or use an underwater camera.

A cheap solution for splash protection is to put a large ziplock bag over the camera, and then cut a hole in it for the lens. Stick your hand in the ziplock side and start shooting. This isn't a perfect solution, but it minimizes how much of the camera gets wet. Just keep checking the lens and drying it immediately with a lint-free lens cloth.

For the occasional picture in wet conditions, consider purchasing one of the single-use (disposable) underwater cameras on the market. They work down to a depth of about sixteen feet and produce good results in bright, sunlit situations. With these, you can get in the pool with the dog and shoot up at the swimming legs, or shoot "half-in, half-out" pictures where the lens is partway submerged, as with the image on page 8.

If you're serious about your waterside and wet-weather photography, consider inexpensive underwater housings, such as those made by Ewa-Marine. These housings look like industrial-strength ziplock bags with a built-in filter for the lens and a glove for your hand. They come in many different sizes for everything from point-and-shoot cameras to larger SLRs with accessory flash. Most allow you to descend with your camera to depths of thirty feet or more. Fancier hard-shell housings are available for particular camera units; check with the camera's manufacturer.

If you're a recreational diver, you might want to consider a deep-water underwater camera (such as those made by Nikonos or Sea & Sea) that can do dual

The most affectionate
creature in the world is a wet dog.
—AMBROSE BIERCE

Snowy days can be a wet hazard for your camera, too.

duty. Just because this type of camera is made to withstand the pressure of deep diving, doesn't mean you can't use it to take pictures in shallow water or on rainy days, as well.

Note that regardless of what type of camera you use, once your camera is wet, you can't just flip it open to change film, digital memory cards, or batteries. It must be thoroughly air-dried first.

Coming in from the Cold

You might not think of cold weather or air conditioning as a water hazard, but it is. Any time you move a camera from cold to hot or vice versa, condensation can form on the outside of your camera. If you open the camera back on a film camera, or remove a memory card on a digital camera, the inner electronics can gather condensation, as well. It's a good idea to seal your camera inside a ziplock bag before going into, or coming out of, extreme cold. Leave it in the bag until the temperature of the camera is close to the new ambient temperature. This will insure that any condensation forms on the outside of the bag and not your photographic gear.

Any time you get dogs near water, whether for a swim or a bath, you're almost doomed to get wet when they come running back to you and shake. Protect even water-resistant, so-called weatherproof cameras from direct spray, mist, and rain.

Film

Love your film camera? Keep it! Digital photography is certainly popular, but there's still a place for the film photographer. Perhaps you have a perfectly good film camera and don't want the expense (and learning curve) of going digital. Or, you have professional or semipro photographic aspirations but can't afford a super-high-resolution digital camera just yet. Don't worry! Film is still a very viable option. You can always scan your prints and negatives if you want to use your pictures on the computer (see page 126).

Even if you're shooting 100 percent digital, the basic concepts regarding film are still important to understand. Low-light capability, contrast, color, and tonal reproduction are all factors controlled by the digital camera's imaging sensor and on-board computer, which together are the equivalent of film. The *equivalent ISO* settings on most high-end digital cameras relate directly to film speeds, or ISOs. As with film, higher equivalent ISO settings provide better low-light capability, but they come at a cost in terms of overall quality. (More on this in a moment.)

Gather several photographers in a room and start talking film, and you'll learn that most serious photographers have their favorite films and are very loyal to a particular film brand, if not to an individual type of film within the brand. You'll also find that such preferences vary greatly from individual to individual.

There are numerous brands of film, including the big names: Kodak, Fuji, Agfa, Konica, and Ilford. These manufacturers produce films that have different characteristics in terms of color, contrast, tonality, and overall quality. Films are made for different purposes, in the process sacrificing certain qualities to enhance others. As a result, there are minute, and sometimes quite visible, variations in the way different films record an image.

Even within the same company, some manufacturers have different brand names for different markets or specialties. For example, Kodak makes a slide film called Elite that is marketed primarily to the advanced amateur photographer, as well as a professional line called Ektachrome. The decision about which film is "best" often comes down to individual aesthetic choice. Try the various brands and decide which you like the best.

Film Speed

One of the first decisions you will need to make is which film speed to use. Speed—a measurement of the film's light sensitivity—is measured in terms of ISO numbers: the lower ISO numbers are "slower," and the higher ISO numbers are "faster." Slow film are less sensitive to light, while fast films are very sensitive to light and can record a proper exposure in dim light.

So-called slow films—ISO 100, ISO 64, and lower—tend to have better overall quality than faster films. Their colors and contrast are brighter and truer, and they produce smoothly gradated tones. They are designed to be used in bright situations for the best results and are a great choice for outdoor pictures of your dogs on sunny days with high-end cameras. You can use slow films in dimmer lighting, but the low light level may mean you won't be able to achieve action-stopping shutter speeds, and that can result in blurred pictures.

Faster films allow you to freeze the action in dimmer lighting situations. As you move into higher ISO films, you'll also start to see a comparative degradation in quality. Your pictures could begin to appear grainy, especially when enlarged. The color and contrast may suffer, as well.

Due to differences in the performance of films of different speeds, some experienced photographers are constantly changing from one film to another, depending on the amount of light hitting the subject. Others choose a favorite film and use accessories, such as a flash or tripod, to compensate. Still others select the middle ground and use a midrange film like ISO 200 or ISO 400 most of the time.

Your choice of film speed will depend on the type of camera you're using. SLR users can use slower, better-quality films because their cameras tend to have "faster" lenses, stronger flash, more shutter speed choices, and the option of using a tripod. Most point-and-shoot users should, at minimum, use ISO 200 for general outdoor shooting, ISO 400 on overcast days, and ISO 800 for action or indoor photography. Low-end point-and-shoot cameras perform best with ISO 400 and faster films all the time.

X-RAYS & FILM

Powerful X-ray machines can fog your film, causing light streaks or reducing overall contrast. Heightened security at airports and other transportation hubs has changed the rules about X-raying film. The airport machines that screen your checked baggage now do more damage than the ones that screen carry-on luggage. The best approach is to ask to have your film hand-checked. If this is not allowed, run it through the carry-on X-ray machines. Technology changes rapidly, so check the Internet before you travel for any new advisories concerning film and X-rays.

The faster the film speed, the more prone it is to X-ray damage. The effect is also cumulative, so multiple X-rays can "add up" to visible blemishes on the film. Therefore, record how many times unprocessed (either unexposed or exposed but undeveloped) film has gone through the machines. (X-rays don't affect processed film.) If you'll be going through a lot of security checkpoints, consider buying fresh film as you travel and having exposed film processed in cities along your route.

Prints or Slides?

Your next decision is whether you want to shoot color print film, which yields a negative that is made into a print, or slide film, which yields a positive image on transparency film. Color print film is a good choice for the family album, and it's the easiest and most economical option. Serious amateurs and professional photographers prefer slide film, often in the form of a 2 x 2-inch mounted slide. This is because slide film tends to have better grain and reproduction quality than negative film, and many of their clients require this superior quality. You can have prints made from your slides, but it's usually more expensive and takes considerably longer than bringing a roll of negatives to a one-hour lab for printing.

With these advantages, everyone would shoot slide film if it weren't for several disadvantages. For starters, slide film requires precise exposure. While you can still get good results with color print film if you accidentally under- or overexpose it, the same is not true of transparency film. The exposure must be so precise that photographers often bracket (intentionally shoot a series of pictures of one subject that are slightly overexposed, normally exposed, and slightly underexposed) to make sure they get at least one perfect exposure. Obviously, this can be expensive in terms of the quantity of film required.

Slide films are also more expensive to purchase, process, and print. They're more susceptible to damage from heat and age, and have a comparatively short shelf life. Unless you are a serious amateur or professional photographer, you'll probably be happy with color print films.

Print films produce negatives that can be printed at any one-hour lab. A negative is a reverse image on film. Slide films produce a positive image on film.

Load Your Film in the Shade

• •

To capture an image that's free of unintended exposure to light, keep your film in its plastic container and in a dark place whenever it's not in the camera, and try to load it in a dimly lit area. Direct sunlight hitting the film or even the canister can cause streaks and bright spots on some of the frames. Film loaded in direct sunlight could be ruined. At the very least, turn your back to the sun and load the film while shading the camera with your body.

So-called black-and-white films are actually made up of shades of gray, rather than black and white. They can also be toned sepia, blue, or another color for an antique or artistic effect. This can be done on the computer or in the darkroom.

Color Balance

Film is also offered in different color balances. Photos taken indoors under household lamps often look yellow because most films are balanced for daylight use, which has a bluer color cast. Compared with outdoor light, tungsten bulbs, such as those used in household lamps, give off a yellower light. Our eyes quickly adjust and make everything look "normal," but film cannot do that.

Tungsten-balanced films make images taken under tungsten lights look normal in color. However, if tungsten film is shot outdoors, the result is a pale bluish image. Fluorescent lighting, which is on the green side, doesn't look great with either film. A light-pink filter will help correct the color.

Black-and-White Film

When color film first became readily available in the 1930s, photographers fell in love with the new technology. Today many fine art photographers have returned to the black-and-white medium because of its inherently different view of the world. Our eyes see the world in color, so images rendered in tones of gray give us an alternate view and turn our

attention to the noncolor elements of photography, such as texture, shadow, and composition.

Classic silver-halide black-and-white film is processed in a darkroom, either by the photographer or by a lab. In the darkroom, you have immense control over the final look of the image. You can increase or decrease the contrast, *burn* certain areas to make them darker, and *dodge* other portions of the image to make them lighter. Another big plus is that, during the shooting stage, you can purposely under- or over-expose an image and then alter the development time to compensate. This technique allows you to increase or decrease the tonal range of the image and otherwise alter its quality and artistic effect.

If you want to try black-and-white film but don't want to take the time to learn or use a darkroom, try chromogenic black-and-white films. Unlike normal silver-halide films, these are dye-based, like color negative films. This means your local photo minilabs can process and print them on the same machines they use for color prints. You'll get back gorgeous sepia-toned images for a lot less money (and time) than it takes to develop and print traditional black-and-white negative films.

Both types of black-and-white films enable you to use color filters to selectively change the tones in the images you shoot. For example, putting a red filter over the lens will give your black-and-white landscape images extremely white clouds against a vibrant sky. (See page 35 for more on filters.)

Still easier is a digital conversion of a color image to grayscale or an antique sepia or blue tone—done on the computer using photo-imaging software, such as Photoshop. (See page 126 for more on digitizing your film images.)

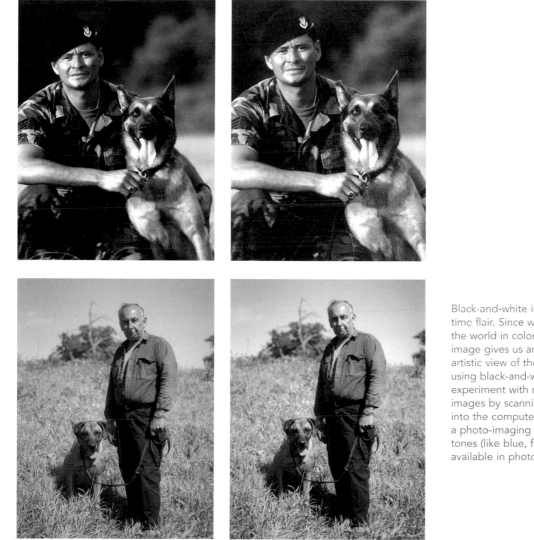

Black-and-white images have an old-time flair. Since we're used to seeing the world in color, a monochromatic image gives us an inherently different, artistic view of the world. If you're not using black-and-white film, you can still experiment with monochromatic images by scanning your color images into the computer and altering them in a photo-imaging program. Additional tones (like blue, for example) are also available in photo-imaging software.

Digital Basics

Digital cameras generate digital images (made up of electronic data rather than exposed onto film). It's a little more complicated than that—but not much. Digital cameras offer a few features that film cameras don't, but it's the recording medium that's the basic difference. Digital camera types fall into the same formats as film cameras, i.e point-and-shoot or SLR.

In the simplest terms, a digital picture is a computer-language file that describes what a picture should look like. Most digital cameras have a monitor or LCD (liquid crystal display) screen on the back of the camera body, and moments after you've taken a picture, it is saved as a file onto digital media in your camera (a memory card or stick, for example, which is similar in concept to a computer disk) and you can view it on the monitor. On some cameras, you can compose the image using this monitor rather than the viewfinder. This makes shooting "from the hip" or at odd angles much easier.

To save images more permanently, you'll need to transfer them to a computer or microdrive, or burn them to a CD or DVD (usually via a cable, memory card reader, or wireless connection).

Once on the computer, the digital files are "read," and the data creates photographs you can see on your computer monitor. They can be sent to a printer or shared with other computers via a cable, e-mail, or upload to a Web site. They can also be manipulated and changed with photo-editing or graphics software (also see page 128). A few fancy printers let you print the pictures directly from your camera or memory card, without using a computer.

Pixels Make the Picture

A digital image is created from individual picture elements, called pixels. The word *pixel* is derived from a combination of the words *picture* and *element*. Each pixel holds a little bit of the picture, like an individual piece in a jigsaw puzzle. When all the pixels are put together, the picture emerges. The more pixels in a picture, the higher the resolution. Not all pixels are the same, so resolution alone is not the final factor in determining quality. In general, however, the higher the resolution, the more detail a digital picture can hold—and the higher the quality of the image.

The number of pixels (dots) in a picture determines the pixel resolution. One million pixels equal one megapixel. So, a picture that's 1,000 pixels across and 1,000 pixels high is 1 megapixel in size (1,000 x 1,000 = 1,000,000 pixels, or 1

megapixel). Picture resolution can also be indicated in terms of pixels per inch (ppi). So a 1-megapixel image measuring 1,000 x 1,000 pixels could be described as 10 x 10 inches at 100 ppi (10 x 100 = 1,000).

Resolution is important in digital photography. If a picture has too low of a resolution (is *low-res*), it won't look good when it's enlarged. The top photo is extremely low in resolution—so low that it breaks down into large blocks or dots (or becomes *pixelated*). The bottom photo is high enough in resolution to create a continuous photographic-quality picture when reproduced in this book. (See pages 22 and 127 for more on resolution.)

Pixels and Printing

Certain output devices (such as computer monitors, inkjet printers, and traditional photo printers) require a certain number of pixels (or dots) per inch (ppi or dpi) to give good results. (Though technically different, the terms *dpi* and *ppi* are often used interchangeably.) If you know the ppi you need, you can multiply it by the final size you want in order to determine how high a resolution you need. For example, many PC computer monitors are set at about 100 ppi, so to create a 4 x 6-inch image on the monitor for e-mailing, you'd need an image that's at least 400 x 600 pixels in resolution.

Inkjet prints usually look good at 150 ppi (or greater), so that translates to 600 x 900-pixel resolution for a good 4 x 6-inch print. Don't confuse the ppi specification with the dpi (dots per inch) specification on your inkjet printer, which relates to how the ink is put on the paper, not the ppi requirements of your digital picture. Since 200 to 250 dpi is recommended for 4 x 6-inch digital prints made by a minilab photo printer, you'd want a resolution of from 800 x 1,200 pixels to 1,000 x 1,500 pixels for good results.

For any of these applications, you could use resolutions that are higher than necessary, but they'd take longer to process, send, and print—sometimes much longer! Most photographers shoot or scan at a high resolution so that they can have all the pixels they may need, but then they also save copies (with slightly different names) at lower resolutions as the need arises.

Memory

There are a few features on a digital camera that you won't find on a conventional film camera. They include removable memory, digital zoom, and settings for file format, resolution and piture size, color mode, ISO equivalents, and "video bursts" or "movies."

Digital cameras require *memory* to save the digital image files when you take a picture. Memory is usually measured in terms of megabytes (MB). Most digital cameras use removable memory, not unlike the way your computer can save files to a CD (which has about 700 MB of memory) or the now archaic floppy disks (1.4 MB).

Different camera models use different formats of removable memory, most of which can be erased and reused over and over. Common types include Secure Digital (SD) memory cards, xD-Picture Cards, compact flash cards, SmartMedia cards, and Memory Sticks. Whatever the form, removable memory can be removed from the camera and swapped, in much the same way that you switch rolls of film-except you can erase and reuse digital media over and over again. They are available in different capacities, for example from 64 megabytes (64 MB) up to several gigabytes (1000 MB per gigabyte).

Once a memory card is full, you should download (transfer) the images to your computer and then ultimately burn them to a CD or DVD for safekeeping. To transfer images to the computer, you use a card reader, a cord, a dock, or a wireless transfer, depending on your camera.

Digital Zoom vs. Optical Zoom

The *digital zoom* feature on digital cameras is not as good as it sounds. Digital cameras with *optical zoom* lenses are great, because the lens works to alter the angle of view to give you wider or narrower (magnified) fields of view. Using an optical zoom lens does not affect the resolution of the picture, because the zoom happens before the light hits the imaging sensor and the exposure is taken.

Perhaps a little misleading in name, *digital zoom* is unrelated to the lens. It merely crops the center portion of the already-exposed image file, making it appear that you have zoomed in to a more telephoto setting. However, digital zoom it is basically just cropping. Moreover, digital zoom does not utilize the entire imaging sensor and, thus, effectively reduces the resolution. If you're shopping for a camera, compare only the *optical* zoom specifications (not the digital) if you want to compare apples to apples. Then, turn off the digital zoom feature when you're shooting. If you want to make the subject bigger in the final image, move closer. Or plan on cropping it later with photo-editing software—the results will be better that way.

File Formats

Some digital cameras offer the option of two or more file formats. By far, the most common file format for digital photographs is the JPEG (pronounced "jay-peg"). The JPEG (Joint Photographic Experts Group) file is a compression format, meaning the file size can be greatly reduced without too much degradation of overall image quality. This enables more picture files to fit onto your digital media. But, you should be aware that there will be some image degradation, however slight. File names of JPEG photographs end in the file extension ".jpg"; the extension may be hidden in some Mac and PC operating systems.

Some cameras shoot in a high-quality *raw*, or proprietary, format that requires special software to view or convert the images into standard file formats. TIFF (Tagged Image File Format) is another format found on some cameras. It's a professional format that has a larger file size than JPEG with no image degradation. TIFF is the preferred format for high-end retouching and for reproduction in

magazines and books. File names of TIFF photographs end in the file extension ".tif"; again, this extension may be hidden in some Mac and PC operating systems.

Resolution

Most cameras offer resolution/picture-size settings. For a given amount of memory, you can choose between shooting a lot of smaller images (those with lower resolution and fewer pixels) that can't be enlarged to huge prints, or shooting a smaller number of larger images (those with higher resolution and more pixels) that can be printed in poster sizes or used for professional applications. Since a 3-megapixel image can easily be enlarged to a beautiful 8 x 10-inch picture, you may decide to select this size even if your camera has 5-megapixel capability. The file for a 3-megapixel picture is considerably smaller than one for a 5-megapixel image, so you can take more 3-megapixel pictures before you have to stop and change memory cards.

On the other hand, if you think you'll want to greatly enlarge your photos or publish them in a magazine or book, you should switch to the highest resolution your camera offers. The same is true if you think you might crop the image later, because cropping reduces the overall resolution as you "throw away" parts of the picture.

Assuming you have a fairly modern computer with fast processing speeds and the ability to burn CDs or DVDs, I'd recommend shooting in the raw, or highest quality, setting whenever practical. You just never know when one of your pictures will be an all-time "winner," and you will want it enlarged to poster size. The only downside is the extra computer processing time and larger file memory requirements. If you find that your computer has trouble handling these larger picture files, you may have to switch to a smaller picture resolution (with fewer pixels) or lower picture quality (more compression)—or switch to a new computer!

ISO Equivalents

Cameras that offer multiple equivalent ISO settings are handy, too. Like film, higher-number (faster) ISO figures offer better low-light capability. Also, similar to film is the fact that the low-light capability comes at a price: Higher ISO settings result in the reduced overall quality of the image, often seen as graininess. And digital cameras with better low-light capability generally cost more.

Color Mode

This handy feature gives you minute control over the color of your images. In its simplest form, color mode lets you select between color and grayscale (commonly called black and white). Some cameras add saturated color, sepia (brown-toned grayscale), and similar options. A few high-end cameras provide color-temperature control that allows you to correct overall color casts. All of these color modes can also be achieved with photo-editing software. Many photographers prefer to shoot with the neutral or auto-color mode and manipulate the effects later, an approach that allows them more options.

Common color modes are Normal, Saturated, Grayscale or Black and White, and Sepia or Antique.

We are **alone**, absolutely alone . . . and amid all the forms of life that surround us, not one, excepting the dog, has made an **alliance** with us.

—MAURICE MAETERLINCK

Normal

Saturated

Grayscale

Sepia

Lenses

Your camera's lens has a huge impact on how your pictures look. Before either a film or a digital camera records an image, the light needs to pass through the optical elements of the lens. The lens can be either built into the camera or interchangeable, as with most SLR cameras. Lenses vary in optical quality, optical design, and focal length. The focal length of your lens (or focal lengths in the case of a zoom lens) affects how the picture looks. Focal length determines how much the lens alters the scene in terms of angle of view and magnification. Lower focal lengths (such as 28mm) show a wider view, while higher focal lengths (such as 200mm) magnify the scene, similar to binoculars.

Focal length numbers stay consistent for 35mm film cameras but change if you use smaller (Advanced Photo System, or APS) film, larger (medium- or large-format) film, or digital cameras (the imaging sensor changes size with the model). If you're using any camera other than a 35mm film camera, refer to the *35mm film equivalent* focal length numbers in your instruction manual to convert the references in this book.

Focal Lengths

Zoom and interchangeable lenses offer a wide range of creative choices. One of the most valuable features of a high-end camera is the ability to change the focal length of the lens. On point-and-shoot cameras this means using the zoom lens setting, which is usually operated by buttons or a toggle switch marked W (for wide angle) and T (for telephoto) settings. On SLR cameras, zoom lenses often have a ring on the barrel that you rotate when you want to zoom the lens from wide to telephoto. On most SLR cameras, you also have the option of switching lenses entirely.

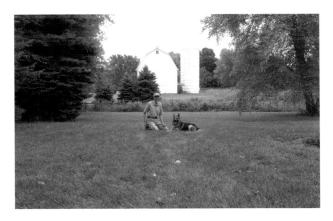

35mm lens

If your camera has a zoom lens or you can change lenses, you'll have a lot of creative control over your picture. In this series, I stayed in one place and changed focal lengths to get progressively closer looks at the subject. With a 35mm wide-angle lens (top), the subject appears small and distant, but the background scenery is present. As my lens focal lengths got longer (indicated by higher numbers), I was able to eliminate more and more of the background. With the 320mm super-telephoto lens (opposite, bottom), I could eliminate my Uncle Fred from the composition completely, leaving only a head-and-shoulders portrait of my dog Yukon.

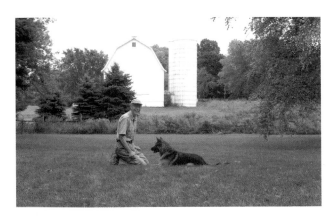

50mm lens

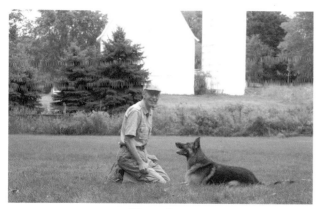

70mm lens

85mm lens

115mm lens

160mm lens

320mm lens

Wide-Angle Lenses: 28mm and 35mm

Lenses with a smaller focal length are called wide-angle lenses because they show a wide angle of view of the scene in front of you. A standard wide-angle lens is 28mm or 35mm, while an ultra-wide-angle ranges from about 15mm to 24mm. One of the biggest assets of wide-angle lenses is that you can fit a lot of things into the picture, even if you're close to the subject. This feature makes a wide-angle lens a great choice for, say, shooting a family portrait with people and pets in the living room.

Wide-angle lenses are popular with landscape photographers because they make landscape scenes seem vast. This works well in dog photography when you're trying to show a dog in its surroundings, such as perched high on a fallen tree or on the edge of a cliff.

Wide-angle lenses also offer relatively close focusing distances (compared to telephoto lenses) and better relative depth of field. When used close to the subject, they can cause distortions,which can be either a disadvantage or an advantage depending on your creative intent. Fisheye or ultra-wide-angle lenses (such as 15mm or 18mm) cause the most distortion, but they provide an extremely wide angle of view.

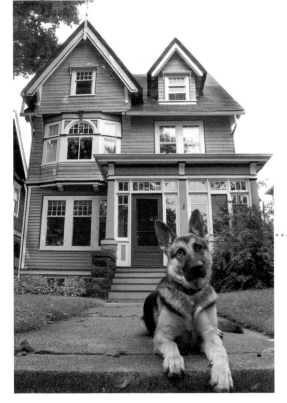

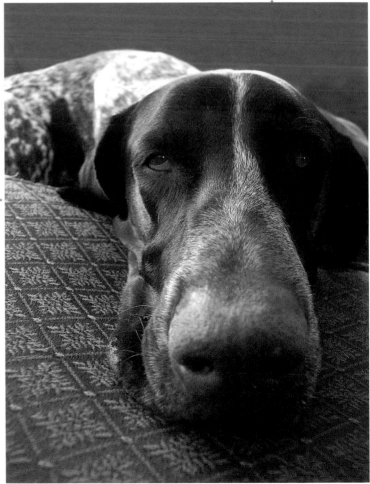

Portrait Lenses: 80mm to 135mm

Wide-angle lenses are certainly convenient for dog portraiture, because you can shoot the pictures at a very close range. This allows you to hold on to your dog's leash *and* take your dog's picture simultaneously. However, wide-angle lenses tend to distort dog features—a phenomenon that becomes more dramatic the wider the angle of the lens (that is, the lower the focal length number, such as 20mm or 28mm) and the closer you are to the subject.

You'll get much better portraits if you step back and switch to a moderate telephoto lens (see the bottom image on page 48), or use the T lens setting on a point-and-shoot camera. Many photographers consider 105mm the ideal portraiture setting for people and dogs, but anywhere in the range of 80mm to 135mm is suitable.

Some cameras have a portraiture mode, usually labeled with an icon of a face. This mode usually sets the camera's lens to the Telephoto (T) zoom setting and weighs the exposure toward a wide aperture to blur the background.

NOSE PRINTS ON THE LENS

When you point your camera at them, most dogs find it irresistible and almost impossible not to come running to you. They somehow think the camera lens is an open-armed play bow or invitation to "come." I probably spend more time trying to keep dogs away from my camera—and nose prints off the lens!—than actually shooting pictures.

There are a few ways to combat this syndrome: (1) Train a bulletproof "stay" command; this hasn't worked with my dogs, unfortunately! (2) Recruit a wrangler, an assistant who stays just out of camera range to hold the dog's leash or to reinforce the "stay" command with voice or treats. (3) Zoom to the Telephoto (T) setting on your camera, or switch to a long focal length lens (such as 200mm) if you have an SLR camera; this will let you take candid images from a distance—far enough away that the dog isn't as distracted by you. And (4), become resigned to the fact that your camera is destined for lots of nose prints, so carry extra lens cleaning materials. At the very least this would be a microfiber, lintless lens cloth; ideally, it is a kit with lens cleaning liquid, paper, and even canned air.

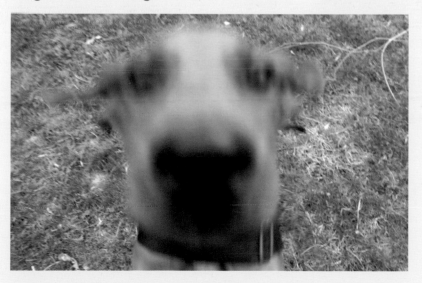

To help protect the camera lens from nose prints, SLR photographers can add a UV filter to their lens.

Telephotos and Super-Telephotos: 135mm and Higher

Beyond the 135mm portraiture range are the "long" lenses with high focal length numbers. Technically, the word "telephoto" refers to a particular lens design. However, it is commonly used to describe any lens with a long focal length (such as 80mm and higher), which is how I'm using it here. These lenses magnify the subjects, making them seem closer and larger in your pictures than they actually are.

One big advantage of telephotos is that you can shoot distant subjects, such as an agility show or coursing event, even when you can't get close. The second advantage is that you can take pictures of your dogs playing in the yard or at a dog park without being close enough to distract them.

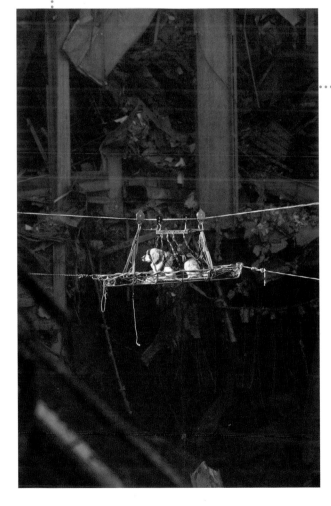

U.S. Navy photographer Preston Keres used a super-telephoto lens to photograph Riley, a search-and-rescue dog being transported across the rubble of the World Trade Center after the 9/11 terrorist attack.

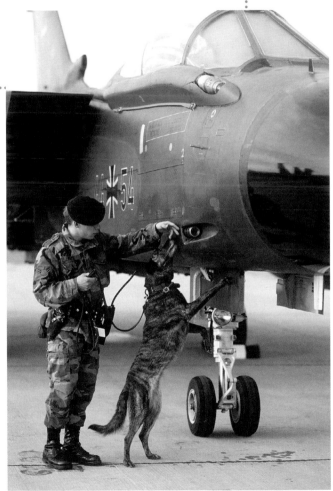

Moderate telephoto lenses are also a good choice for candid photography when you want to be far enough back from the dogs so as not to distract them, yet close enough coach any human models.

TELECONVERTERS

With most SLR cameras and a few high-end point-and-shoot cameras, you can extend your focal length with a 1.4X or 2X teleconverter, which is a small, light lens attachment that fits between the lens and the camera body. A 2X teleconverter, for example, doubles the focal length, turning a 200mm lens into a 400mm lens for much less money (and less added weight, as well) than if you used an actual 400mm lens. Unfortunately, using a teleconverter results in some minor quality degradation and a loss of light (a full 2 stops less light for a 2X teleconverter).

You can get a frame-filling picture of a distant subject using a telephoto lens or a teleconverter on an SLR camera, or using the Tele (T) setting on a zoom lens.

Macro Lenses

Macro and close-up lenses, or close-up settings on some point-and-shoot cameras, allow you to take a picture from a closer distance than most lenses, magnifying the subject. When would you use this in dog photography? How about for a close-up of your dog's beautiful eyes? Or a frame-filling picture of your dog's face?

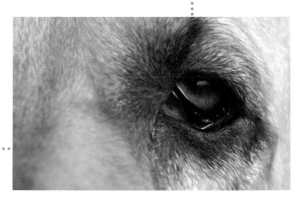

The closer-than-normal focusing distance of a macro lens enabled me to fill the frame with just a small part of this dog.

For Point-and-Shoot Users: Don't Miss the Shot

Since point-and-shoot cameras have two lenses—one for the lens and one for the viewfinder—the pictures made with these cameras can suffer from *parallax error*, meaning the film image may be different from what appears in the viewfinder.

For distant subjects, the difference in the angles of these lenses is negligible in the final image. But as you move closer to your subject, the problem can become more pronounced. The first photo below represents what I saw in the viewfinder. The actual result was the following image because of parallax error.

To understand this phenomenon, hold your finger twelve inches in front of your face. Close one eye and position the finger so that it blocks an object in the distance. Without moving the finger, open the other eye and notice that the distant object is no longer covered. Just the few inches of difference in the placement of your eyes causes the lines from the eyes to the finger and the background to be at different angles.

In some cameras, parallax-correction frame markers in the viewfinder help you avoid chopping off key areas. If your camera lacks this feature, don't compose too tightly when you're very close to your subject. You can always crop the image later.

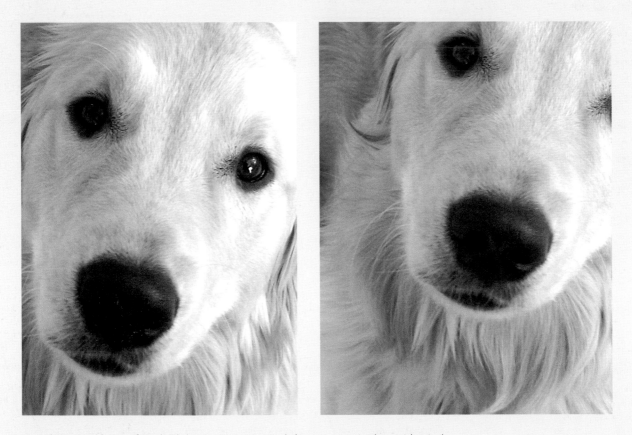

At a distance, the view from both lenses in a point-and-shoot camera is almost identical.
But as you move in close, you get the photo at right—rather than the photo at left—
because the viewfinder lens is on a slightly different axis than the actual lens.

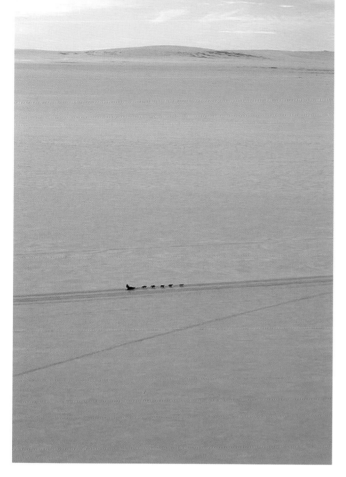

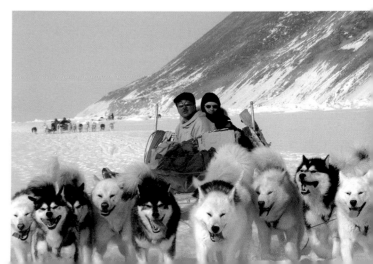

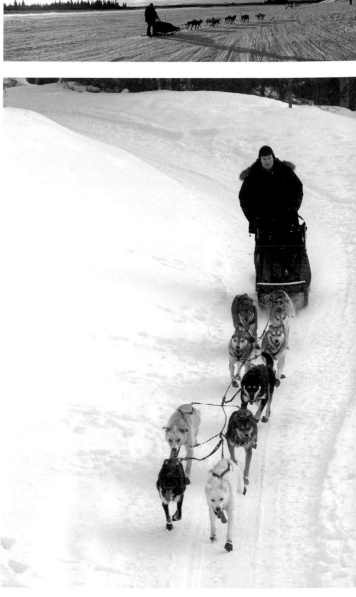

Lens Variety

Professional photographers usually carry a camera bag with several different lenses so that they're ready for any photo opportunity that arises. For the same reason, a point-and-shoot camera with a zoom lens will give you a lot more creative choices than one without. In the world of digital photography, the wide-angle settings are the hardest to manufacture, so truly wide angles are only found in higher-end cameras. If wide-angle capability is important to you, check the *35mm focal length equivalent*, and shop around for the widest choices (the lowest-number focal lengths).

A variety of lenses (or a camera with a zoom lens) gives you a lot of creative choices. Here, U.S. Air Force photographers Tech Sgt. Keith Brown and Tech Sgt. Dan Rea used several different lenses and camera positions to tell the story. A wide-angle lens used at a distance shows a dog-sled team in a vast, desolate environment (above). A wide-angle lens used closer to the subject still shows a wide field of view but presents a more intimate shot of the action (top, right). A telephoto used at a distance tells the story of the race but brings the view closer to the action (middle, right). And a telephoto used at eye level and close to the subject creates an image with a lot of drama by filling the frame with action (bottom).

Candid Canines

Most people assume all candid photography requires a telephoto lens so that you can be a discreet distance away from your models. While this is true for people (or pictures that include people and dogs), most dogs will ignore you if they are busy with an exciting activity.

I like to go into the yard with my dogs, Yukon and Ajax, and get right in the middle of their play-fights. I use a digital camera in autoexposure mode on a wide-angle setting and hold it out at arm's length, very close to them as they jump and bark and play. The automatic shooting mode takes care of autofocusing and exposure. Some of the results are good, some are bad. But they're always exciting.

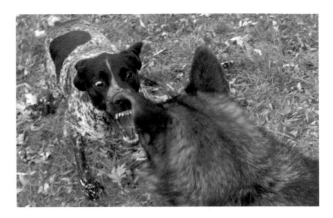

Yukon and Ajax, completely distracted by play.

Lens Distortion

If you stand in one position and zoom a lens, you're basically cropping the picture. You're reaching out and bringing the subject closer so that it will appear larger in the final image. Little else changes in the picture, with the exception of minor optical "distortion" related to the lens construction (which can be both good and bad). It's not until you change your shooting position (or move your subjects slightly) that you can really start altering the relationships between different elements in the picture. Understanding these changes means you can use them to your creative advantage.

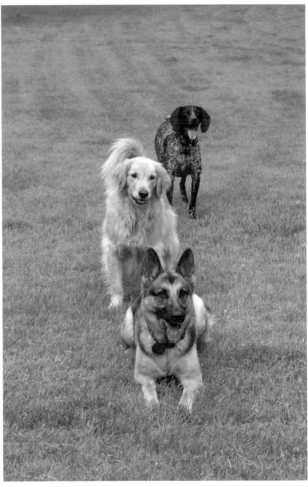

In the picture above, it appears that the dogs are just lined up at equal distances to one another. However, to get them to stack up and *look correct*, I varied their distances. The distance between the middle and farthest dogs is actually much greater than the distance between the middle and nearest dog.

For Trucker's official Search & Rescue Dog portrait, I used a telephoto lens for a dignified, classic look (far left). However, when we were having fun later, I switched to a 20mm lens and moved in close. The distortion is very obvious. Trucker seems to have an enormous nose in the wide-angle version (near left).

320mm telephoto lens **20mm wide-angle lens**

SHADE YOUR LENS

• •

Flare from the sun can degrade your picture if direct sunlight hits the front glass on your lens. Flare can show up in your photograph as light or colored spots, a bright starburst, stripes, or simply a hard-to-define general reduction in contrast. The easiest way to prevent flare is to shade the lens with your hand, a hat, or a magazine. If you're using an SLR camera, use a lens shade, but make sure you choose the right size shade for the focal length of the lens or you may get vignetting (darkening of the edges or corners of an image). Alternately, reposition yourself and your subject so that the sun is to your back—and therefore not hitting the front of your lens.

And, if you can't beat it, work with it! A small shift in position can sometimes tuck the sun behind the subject to simultaneously shield your camera lens and produce a glowing backlit silhouette. Likewise, a starburst flare can add mood to a backlit, artistic picture.

Most commonly, lens flare is obvious and looks like a streak of light, but it can also result in a more subtle overall reduction in contrast and picture quality. You can, however, use it to generate a creative starburst effect if you include the light source in the picture and use Aperture Priority mode to select a narrow aperture (such as f/16).

Specialized Equipment

Most cameras can be used with a tripod, and a few cameras can accept filter attachments. Both these types of equipment can improve your pictures if used properly.

Tripod for Self Portrait with Your Dog

If you look through my photo albums, you'll see a zillion pictures of my dogs, my friends, and my friends' dogs. But since I'm usually the designated photographer, there are few pictures of me, and even fewer of me with my dogs. That's where a tripod can come in handy! Set your camera on a tripod, prefocus on a bench or spot on the ground, engage the self-timer, get into position in front of the camera with your dog, count down the seconds, and you have a portrait. Most cameras have a self-timer that gives you ten or more seconds to run into place for the picture.

A tripod facilitates taking a picture of yourself with your dog.

Tripod for Portraits

A tripod can also be helpful for portrait stations. If your dog will stay still in one spot for a picture, then you can set up the camera on a tripod and prefocus. This frees you from hiding behind the camera, so you can use your hands and facial expressions to elicit the response you want from your dog. It's also a good choice for camera-shy dogs, because their attention moves away from the scary camera to the person with the pocket full of biscuits who is near the camera (you!).

In addition, it can be very tiring to hold a big camera for a long period of time, especially if you're stooping low for eye-level portraits of your dogs. A tripod will hold the weight for you. This will eliminate blur from camera shake (but not blur from subject movement).

Tripod for Low Light

If you're shooting indoors or at dawn or dusk, the light will be dim and you'll need to use slow shutter speeds. Other times, you might not want to use a flash, so you'll also need to use slow shutter speeds. If you find you cannot get sharp images with these slow shutter speeds, consider a tripod or other camera support. Again, it will help prevent blurriness from camera shake, but a moving dog will still blur, even though the background will be sharp. This is a good accessory to use when photographing sleeping or resting dogs.

Tripod for Action

A tripod can help you with action pictures, as well. It helps steady a camera for sharper images when using long focal lengths. It will also make panned images blur more smoothly. Since action pictures look best if you track the subject in the viewfinder, a tripod with a ball or pan head will allow you to stabilize the camera while tracking. The result will be sharper images at high shutter speeds, and smoother blurs when doing slow shutter speed pans.

Picking the Right Tripod

If the above four tips sold you on the idea of a tripod, you need one more tip—on how to pick the right one. Most people think of tripods as a professional piece of equipment used for holding giant lenses. And yes, they're great for that, but most people don't need the expense (or carrying weight) of a big bulky unit.

Traditional tripods hold the camera steady on three legs. They range from large, heavy models designed for camera and lens combinations that weigh upward of ten pounds, to tiny tabletop tripods that are only a few inches in size. For occasional general use, most photographers will want a lightweight tripod that can be raised to a standing (or slightly below standing) shooting level.

Monopods are the one-legged version you see sports photographers use. Monopods can't hold the camera without your help, but they do assist in holding it steady and bear much of the weight of the camera during a long shooting session. They're not ideal, but they give better results

than handholding alone. And they make a nice walking stick when hiking with your puppy!

Better tripods and monopods have interchangeable heads, so you can pick the style you like best. Pan or ball heads are a good choice for dogs, because they allow you to quickly and smoothly reposition your camera when it's mounted on the tripod. Quick-release plates that can be attached to the bottom of your camera allow you to take the camera on and off the tripod in a moment, without having to screw the camera on each time.

Filters

Filters are one of the most powerful photographic accessories because they can have a tremendous effect on the look of an image. Some can dramatically turn a throwaway image into an award winner. The trick is knowing which filter to use and when. Whole books have been written just on filters and their use in photography. Many types of filters have become obsolete in the digital age because color correction and enhancement are so easily done with a computer. Others, however, such as polarizers, are still standards with professional photographers.

Some filters work by selectively allowing certain rays of light to enter your lens while excluding others. Filters—like diffusion, fog, and speed filters—can bend or scatter the light for special effects.

Polarizers are great for removing reflections from glass, water, and flora. By reducing the reflection or glare, you can get more saturated images. Another popular use for polarizers is to darken blue skies; this produces dramatic skies and renders the foreground lighter in comparison.

These filters come in a revolving mount that you spin while looking through the viewfinder and watching until you achieve the "right" amount of polarization. Note that polarizers don't always work, depending on your angle to the object, how it reflects the light, and the position of the polarizer. In situations in which the effect is too much, you can simply partially turn the polarizer while observing the change through the viewfinder. Most of today's autofocusing cameras require that you use a circular polarizer, because linear polarizers can interfere with the camera's polarization-based autofocus and metering systems.

Colored filters add a warm or cool cast or dramatic tones to a color image (all of which can also be done in the computer). These same filters can be used with black-and-white film for radical shifts in the relationship of an image's tones, such as using a red filter to darken a blue sky without otherwise affecting the clouds.

Most SLR and a few point-and-shoot cameras accept filters. The most common filter is the screw-on variety that attaches to the front of most interchangeable SLR camera lenses. Before buying a screw-on filter, you'll need to know the filter diameter of each of your lenses. Don't confuse *focal length* with *filter diameter*, even though both are measured in millimeters (mm). You can purchase filters for each lens (and each filter diameter size), or use one large filter and get step-down rings to retrofit it to each lens. The latter saves money, but if it's a filter you'll be using a lot, screwing it on and off your lenses can be an inconvenience.

If your camera doesn't take filters, you may be able to use an accessory filter holder made for point-and-shoot cameras. However, these can be difficult to use with polarizers because they must be rotated to the "right" spot; however, you won't be able to see that through the lens, so you'll have to guess. (Remember, with most point-and-shoot cameras you're not looking through the picture-taking lens.)

The most common filters are the UV and skylight filters. Though different, their effect is similar. The UV filters remove ultraviolet light that's invisible to our eyes but can cause a color cast on film. They also reduce haze and glare in some outdoor photographs. Skylight filters, pale pink in color, remove the slight bluish atmospheric haze seen in many outdoor pictures. Both are usually inexpensive, and either has the added advantage of protecting your valuable lens from damage. It's a lot cheaper to replace a scratched filter (or a filter that has had way too many cleanings to remove wet dog nose prints) than a whole lens.

Reduce reflections on nonmetallic reflective objects, like glass, with a polarizing filter.

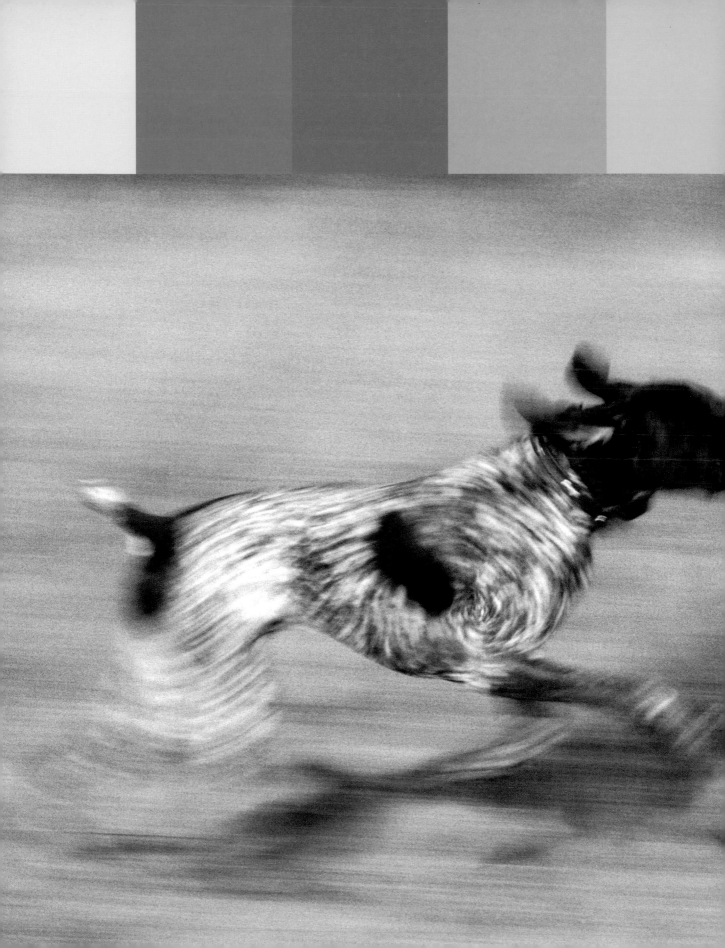

WHERE'S FIDO?
Exposure

2

Have you ever taken pictures that are too blurry, too light, too dark, too grainy, or without highlight or shadow details? (You know, the black Labrador retriever that looks like a black blob with eyes.) If so, it was probably a matter of the camera using the wrong exposure. The "right exposure" is one that is neither too dark nor too light, and has enough of the subject in focus. But exposure choice involves far more than that. Once you become familiar with the basic concepts of exposure, you can use them in creative ways to radically alter and improve the look of your pictures.

The Basics

When your camera takes a picture, it opens the shutter to allow light to enter a hole in the lens for a certain amount of time. This opening in the lens is the *aperture* or *f-stop*, and the amount of time the lens remains open is the *shutter speed*. The light exposes the film (on a film camera) or hits the digital imaging sensor (on a digital camera) to create the picture. A certain quantity of light is needed to make a correct exposure with a given film or ISO setting. Dimmer lighting conditions require longer shutter speeds and/or larger apertures to deliver this needed amount of light for the picture.

Going Faster

There are three major ways to control exposure: (1) choice of film or equivalent ISO setting (on digital cameras), (2) aperture, (3) and shutter speed. Faster films (high ISO settings) need less light to make a proper exposure in a given situation than slower films (low ISO settings). So, you can select a faster shutter speed, a narrower aperture, or both if you choose a faster film or faster equivalent ISO setting on a digital camera. However, this faster speed comes with a drop in quality, with a grainier look, and poorer contrast and color rendition.

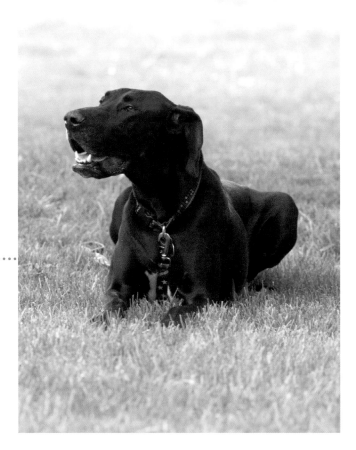

In shade with slow film/ISO setting, you might be able to get a sharp, well-exposed image of a still dog, but shots of a moving dog may be blurry.

Important Relationships

If your camera allows shutter speed and aperture adjustment, you'll have more exposure control. Shutter speed and aperture are mathematically related. Shutter speeds are measured in intervals of seconds or fractions or seconds. Apertures (lens openings) are measured in *f-stops*, such as $f/2$, $f/2.8$, $f/4$, and so on. Changing the aperture 1 full stop is equal to doubling or halving the shutter speed, for example going from a shutter speed of 1/250 sec. to 1/500 sec. (which is twice as fast).

Smaller aperture numbers indicate larger lens openings, while larger aperture numbers indicate smaller lens openings. Common apertures, from largest to smallest, are $f/2$, $f/2.8$, $f/4$, $f/5.6$, $f/8$, $f/11$, $f/16$, $f/22$, and $f/32$. Some lenses have $f/3.5$ and $f/4.5$ aperture settings, but these are half or partial increments, not full-stop increments.

Each full-stop change halves or doubles the area of the lens opening, so either half or double the amount of light enters the lens in a set time period (determined by the amount of time the shutter stays open, i.e. the shutter speed). A larger aperture (say, $f/2$ or $f/2.8$) lets in more light at a given shutter speed. So, you can use a faster shutter speed with a wide aperture than you can with a small aperture.

Like shutter speeds, film speeds or equivalent ISOs are based on the idea of doubling or halving numbers. Doubling the ISO increases light sensitivity by 1 stop. So, selecting ISO 200 instead of 100 lets you go 1 stop smaller with your aperture or one shutter speed faster in any given lighting situation. On a sunny day, instead of using an aperture of $f/16$ with a shutter speed of 1/125 sec. at ISO 100, you could use ISO 200 and select $f/22$ and 1/125 sec. or $f/11$ and 1/250 sec.

The basic idea is that you can juggle shutter speed, aperture, and ISO to control the look of your images.

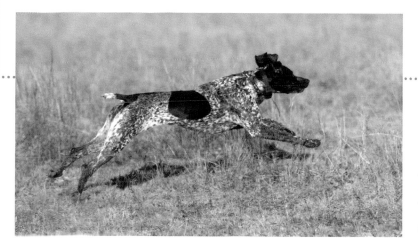

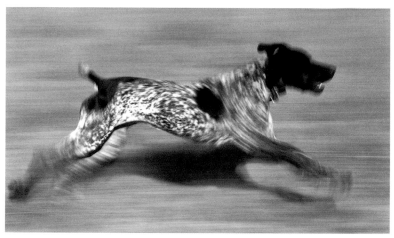

Use shutter speed to control the crispness of an image. A fast shutter speed (one that keeps the shutter open for only a short period of time) tends to render sharper subjects (left). A slow shutter speed (one that keeps the shutter open for a long period of time) can result in a blurred subject—either from camera shake or subject movement (below)—but this is not always a bad thing because blur can be used creatively.

What's in Focus?

While shutter speed affects how sharp or blurred certain elements in an image are, the aperture setting controls how much of your subject is in sharp focus from front to back in the image; this is also referred to as *depth of field*. By altering the aperture size, you control how much of the foreground, subject, and background are in sharp focus.

Larger apertures, such as $f/2.8$ or $f/4$, render less in sharp focus than smaller apertures, such as $f/22$ or $f/32$, which provide greater depth of field. If depth of field is important to you for a certain image, then select your aperture for it, and let the shutter speed fall where it may for the proper exposure.

In the frame-filling portrait at right, the depth of field—or plane of sharp focus from front to back—is very narrow, so the eyes are sharp but the nose and ears are out of focus. Depth of field also affects the relationship between subjects. In the image opposite, the puppy is in focus, while the German shepherd is out of focus. Both could have been rendered in focus with a smaller aperture (such as $f/22$) or with a faster film/equivalent ISO setting in autoexposure or Landscape exposure mode.

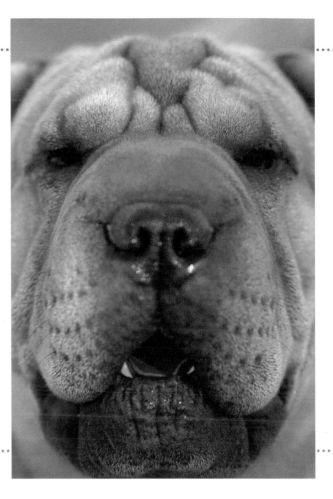

When the Man waked up he said, "What is Wild Dog doing here?" And the Woman said, "His name is not Wild Dog any more, but the First Friend, because he will be our friend for always and always and always."

— RUDYARD KIPLING

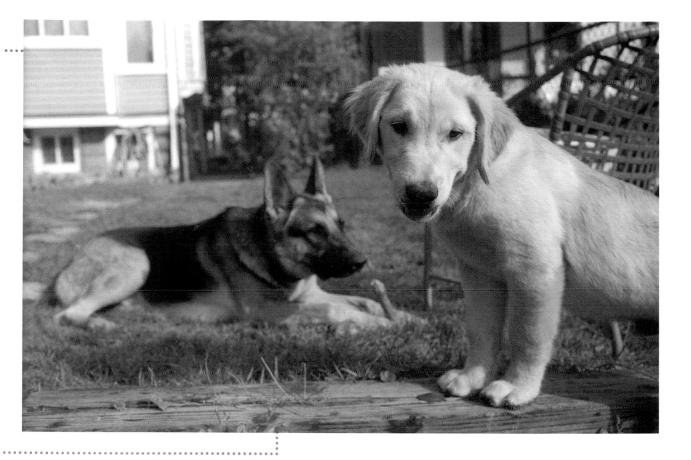

EXPOSURE MODES

Some high-end cameras allow you to alter aperture and shutter speed manually. Others give you exposure modes that do some of the adjusting for you. Most SLR and a few high-end point-and-shoot cameras offer the following exposure modes that let you optimize your exposure decisions: Shutter Priority, Aperture Priority, Program, and manual modes. Since shutter speed determines how blurred things look, if shutter speed is the most important factor to you (for example, if you need an action-stopping shutter speed for a running dog), then choose Shutter Priority mode. It lets you select the shutter speed, and then the camera automatically provides the right aperture. If depth of field is important to you, then choose Aperture Priority mode; select your aperture and let the camera choose the right shutter speed. Program mode selects both the shutter speed and the aperture for you. In manual mode, you select both settings for yourself.

Many cameras have exposure modes based on the type of subject you're shooting. They include Close-Up, Landscape, Action, and Portrait modes, which are discussed throughout the book. These are quick automatic modes that help your camera get good exposures in the specific shooting situations they describe. Use them! They work.

Large vs. Small

As mentioned briefly on the previous pages, a large or wide aperture renders shallow depth of field. So, you can use large apertures to creatively separate the main subject from the background. For example, when you don't want the background to distract from the subject, select a large aperture, such as f/2.8 or f/4 to throw the background out of focus.

When you want to see greater depth of field, meaning more of the image is in sharp focus from front to back, choose a small or narrow aperture, like f/22 or f/32. The sharpening effect will be greatest with wide-angle lenses; you will, seemingly, be able to get less in focus as you switch to lenses with longer focal lengths. It's important to remember that small apertures let less light into the lens than large apertures, so they require slower shutter speeds to allow light in for a longer amount of time. On a bright sunny day, this may not be a problem; f/22 at 1/60 sec. would be a typical exposure for ISO 100. But you may need to switch to a faster ISO if you are using longer lenses (which require faster shutter speeds if handheld), or when working with running dogs or dimmer lighting.

Another alternative is to use a tripod to hold the camera steady during longer shutter speeds. If the dog is moving, however, it may still appear blurred, because a motionless camera only records stationary objects sharply.

f/2.8

This series illustrates the effect of aperture on depth of field. As the aperture changes from larger to smaller, the background moves from soft focus to sharp focus, resulting in very different interpretations of the same subject.

A NOTE ABOUT POINT-AND-SHOOTS

• • • • • • • • • • • • • • • • • •

Point-and-shoot cameras that don't allow exact aperture selection may have sophisticated exposure modes that achieve the same thing. Select Portrait mode or Action mode to get the effect of rendering the background out of focus with a large aperture. Both these modes weight the exposure toward wide apertures and faster shutter speeds.

Point-and-shoot cameras that don't allow exact shutter speed selections may have a Landscape mode to mimic the greater depth of field achieved with smaller apertures and slower shutter speeds.

Dog, n. A kind of additional or subsidiary Deity designed to catch the overflow and surplus of the world's worship.

— AMBROSE BIERCE

DEPTH-OF-FIELD PREVIEW BUTTON

● ●

On an SLR camera and some digital cameras, you're looking through the picture-taking lens as you compose, and in order to see a bright view in the viewfinder, the lens stays open at the widest aperture until the moment of exposure. Some SLRs offer a depth-of-field preview button that lets you see how your chosen aperture will affect the image. Using this feature, however, darkens the image in the viewfinder because the aperture stops down the lens and lets in less light.

　　If you're using a digital camera without this feature, just snap a quick shot and review it in the LCD screen. Use the magnification tool (usually marked with an icon of a magnifying glass and a plus sign) to check the details.

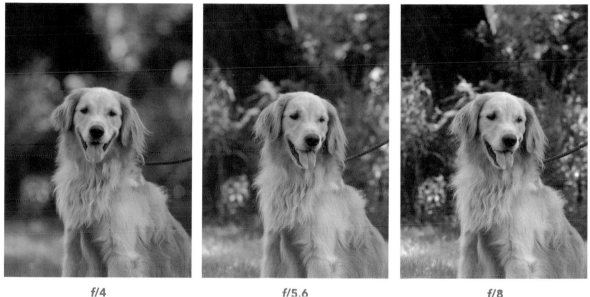

| f/4 | f/5.6 | f/8 |

| f/11 | f/16 | f/22 |

Fast Enough?

The times when you want to freeze action—when your dogs are running or playing—are the times you want to take control of your camera's aperture and shutter speed. To freeze fast-moving subjects sharply, you need a fast (short-duration) shutter speed. Related to this, the focal length of the lens determines how fast a shutter speed you'll need. The higher the focal length, the more magnified the image, meaning that the effect of the smallest bit of subject movement (or camera shake) will also be magnified in the actual picture. So, you'd need to use faster shutter speeds with higher focal lengths and with telephoto lenses than you would with wide-angle lenses.

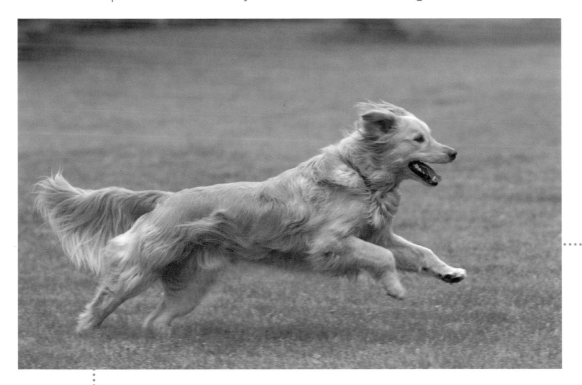

Exactly How Fast Is Fast Enough?

Just to avoid camera shake, you'll need a shutter speed that's *at least* as fast as 1/lens focal length—for example, 1/200 sec. if you're using a 200mm lens. If you're tired or shooting in windy conditions, you may need an even faster shutter speed. Add subject movement, and you'll need even faster shutter speeds.

A fast shutter speed (say, 1/1000 sec.) in Shutter Priority mode (or Action mode on a high-end point-and-shoot camera) gives you a better chance at getting a sharp picture of a running dog. Remember that young, fit dogs (and fast-running breeds) move a lot faster than old, overweight, small dogs in terms of miles per hour. You'll need faster shutter speeds for faster targets.

What If I Can't Get Fast Enough?

If you can't achieve action-stopping shutter speeds, consider panning (see page 100). It's a good technique for optimizing sharpness with fast shutter speeds. And at slow shutter speeds, it can turn the image into a wonderful, artistic blur. The result is a relatively sharp subject against an extremely blurred background.

Some cameras have an Action exposure mode, which weights the camera's autoexposures toward faster shutter speeds. Or, you can use Shutter Priorty mode and select a shutter speed you feel is fast enough to freeze the image based on the subject speed and the lens focal length.

If you're unsure about which shutter speed is fast enough, you can also use Aperture Priority mode and select the lens's largest aperture, such as *f*/4 or *f*/5.6. This will force the camera to match this largest aperture with the fastest shutter speed for the given amount of light.

A shutter speed will yield different results—even all in one picture—depending on the motion of the subject. With a shutter speed of approximately 1/30 or 1/60 sec., the stationary tail, grass, and tennis ball were all rendered fairly sharply. However, the dog's head was in motion and recorded as an almost indistinguishable blur.

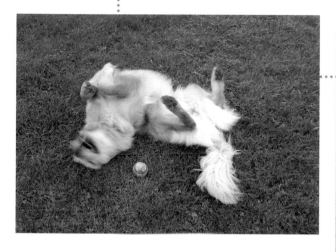

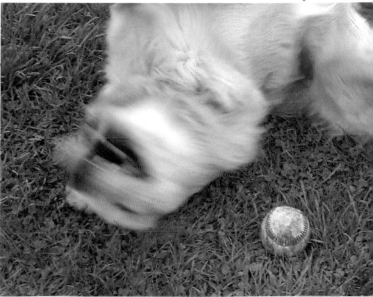

The great pleasure of a dog is that you may make a fool of yourself with him and not only will he not scold you, but he will make a fool of himself too.

—Samuel Butler

Doggone It! (Potential Exposure Problems)

There are several situations in which lighting conditions can make it difficult to get a good exposure. Luckily, color print films are very forgiving, and you can get adequate results with images that weren't shot at the optimum exposure. And many digital pictures can be repaired on the computer. However, you'll get the best results if you take the time to "help" your camera achieve proper exposures. Images that have been underexposed tend to look grainy and have poor contrast, with little detail in the shadows, and they may take on a bluish tone. Overexposed images lack details in the highlights and can look washed out.

High Contrast

High-contrast situations are often beyond the contrast range of most films and digital cameras. The most common example in general photography is when direct sunlight both illuminates highlights and casts deep, dark shadows. The worst example is when this happens on a black or white dog.

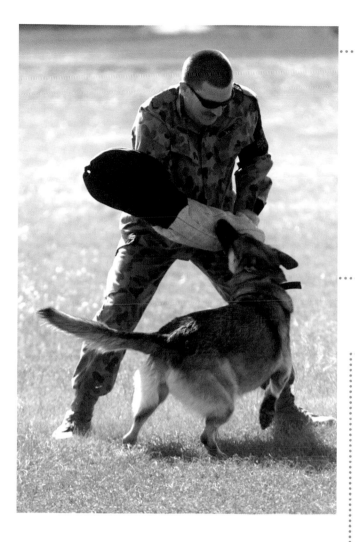

Backlight

Backlit pictures can cause exposure problems for many cameras. If the camera bases the exposure on the shadowed front of the subject, the background can flare out. If it exposes for the background light, the subject will turn into a black silhouette. Somewhere in between an exposure based on the background and an exposure based on the subject is often best. Fill flash (see page 66) is also a good solution.

Black on White

Black or dark dogs are tough to expose on white grounds. Snowy situations can be especially difficult because the bright white snow causes the camera meter to read a lot of light and underexpose the picture, resulting in a black blob for the dog. If your camera has exposure compensation, select +0.5 EV or +1 EV.

Old age means realizing you will never own all the dogs you wanted to.

— JOE GORES

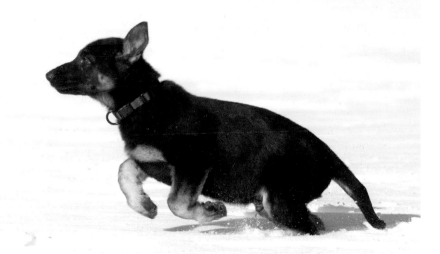

Black-and-White Dogs

Dogs (or any animals) that have large areas of black *and white* spotting or ticking become especially difficult to photograph because of the wide contrast range from light to dark. (The same is true of two dogs next to each other, one with a light coat and one with a dark coat. See page 51.) If you expose for the black portion, the white will be overexposed and look like white blobs without detail. If you expose for the white portion, the white hair will look nice but the black areas will be black blobs without detail. Waiting for cloud cover or moving to shade—and selecting an exposure in the middle—will give you the best result. Shade produces less contrast than direct sunlight. If it's not possible or convenient to get out of the sun, add fill flash (see page 66) to fill in the shadows and reduce the overall contrast.

The next best solution is to shoot digitally (or shoot film and convert to digital). Once your image is in the computer, you can work on improving the details in the highlights and shadows.

Exposure for the black = too light

Exposure for the white = too dark

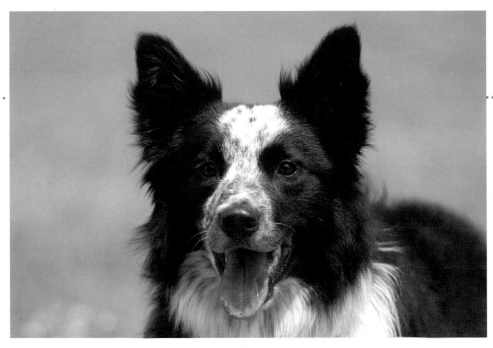

Just right

Exposure compensation +0.5 EV

Autoexposure mode

Exposure compensation -0.5

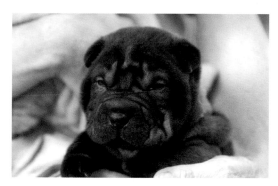

Exposure compensation -1.0

Black Dogs and White Dogs

Dogs that are all black or all white can cause their own problems. Proper exposure of extremely light or dark subjects may require intentional over- or underexposure. Why? Your camera's built-in light meter assumes everything you point it at is a mid-tone gray in terms of reflectivity. Because of this, if your subject is especially dark or light, the meter will want to over- or underexpose the image, respectively, trying to make it that mid-tone gray. The result is either a bluish dog, rather than a white or black dog, or a featureless black or white blob in your pictures.

Black or white dogs trick your camera into creating a wrong exposure, and they can create too wide a contrast range with the other elements in the image for most cameras to handle (i.e., they are too dark or too light compared to the background or highlights and shadow). To combat this problem, do one of four things: (1) Move the dog into deep shade, which has less contrast than direct sunlight. (2) If you must remain in harsh sunlight, turn on fill flash for fairly close portraits (from four to ten feet away); this will fill in the shadows and produce a pleasing highlight in the dog's eyes. (3) Use the harsh sunlight to artistic effect, knowing that you will lose details in the dog's fur. Look for creative rim lighting (when the edge of the figure is rimmed in light) or an angle in which the light produces extreme modeling of the contours of the face. (4) Learn the advanced technique of exposure compensation to get properly exposed images; select +0.5 +1.0V for frame-filling pictures of white animals and -0.5 -1.0V for frame-filling pictures of dark animals (see page 50 for more).

A black dog can fool your camera's exposure meter, even in shady lighting conditions. When you turn the exposure compensation dial the wrong way and add +0.5 EV, the result is the most washed out. In autoexposure mode, the dog still appears light and washed out, as does the owner's hand. An exposure compensation of -0.5 slightly underexposes the image. Setting exposure compensation at -1.0 gets the puppy and hands to look correct.

Get Your Whites Whiter

White dogs (or wolves, in this case) also require exposure compensation. In autoexposure mode, the wolf appears a bit dark. By adding +0.5 EV exposure compensation, the wolf becomes white again.

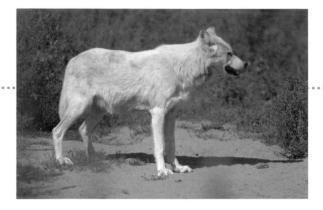 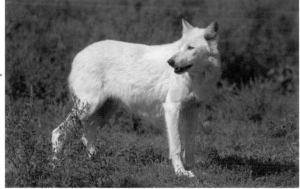

The New Black

Fill flash can help when photographing black dogs in sunny situations because it lightens deep shadows—thereby reducing the overall contrast between the light and dark portions of the picture. Here, it also adds a nice bright highlight in the eyes and causes the reflective stripes in the search-and-rescue vest to glisten. Detail is maintained everywhere but the sunlit portion of the tongue.

A stranger in town is like a white dog, he gets noticed.

—AFRICAN PROVERB

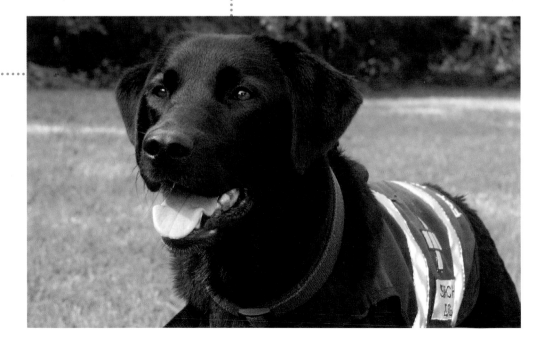

Coats of Many Colors

When placing a light dog next to a dark dog in bright sunlit conditions, you'll have trouble getting details in both highlight and shadows. Faced with two black dogs and one tan one, I chose to overexpose the image, providing detail in the shadow sides of the dogs but rendering the white areas without details. However, the highlights were mostly in the form of rim light (on the backs and tops of their heads and on the steps) rather than making up the bulk of the subject.

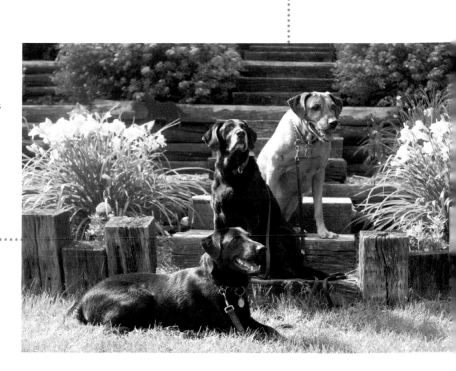

EXPOSURE COMPENSATION

Most high-end cameras do a better metering job than simpler models, because they use *multisegment* or *multipattern metering* (metering several areas in the scene) and sophisticated algorithms to evaluate the information and "correct" the exposure automatically. They do a fairly good job in most situations.

However, if you're getting consistently poor results of your dark or light-colored dog, you may need to take matters into your own hands. Check your camera's instruction manual for information on exposure compensation controls. Exposure compensation will let you intentionally under- or overexpose an image in order to make black dogs look black (underexposure) and white dogs look white (overexposure). Photographers usually select these settings in third-stop (0.3 EV) or half-stop (0.5 EV) increments.

Note that the straight exposure of a black dog without exposure compensation

(on page 49) does not produce a true black because the camera overexposes the image to try to make it look mid-tone gray. Underexposing the image by reducing the light reaching the film (-1.0 V) darkens the image and makes it black again. Similarly, with the white wolf (opposite), the white fur tricks the camera's meter into underexposing the image to try to make it a mid-tone gray. The result is too dark. Adding light through +EV exposure compensation brings the image back to white.

Digital photographers have a big advantage over film photographers because they can shoot and then instantly check their results in the LCD screen. This is a great way to learn how to manipulate the exposure compensation function on your camera. If you don't have a digital camera, you might want to try to borrow one for a day to experiment with this technique. Otherwise, shoot film and record what you do in a notebook. Later, you can match the notes to the pictures to figure out the effects.

LET THERE BE
Lighting

3

The color, quality, and direction of the light illuminating your subject all affect the quality and artistry of your pictures. Plan your poses with the lighting in mind. High-contrast and rim lighting can be dramatic by bringing out the texture of dogs' coats. Soft, low-contrast lighting makes a pleasant portrait. Fill flash can make your pup "pop" out of the background.

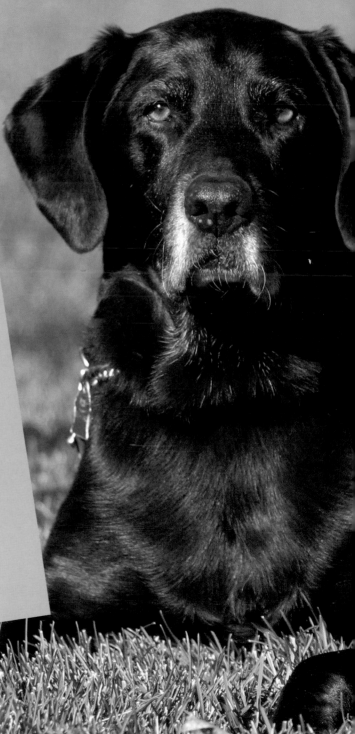

. . . DOGS!

The Color of Light

Sunlight has a distinct quality and color at different times of day, and at different times of the year, and even in different geographical locations. Late-afternoon sunlight has a very warm cast because of its angle and its reflections through the atmosphere. Pollution in the atmosphere, whether man-made or natural (including volcanic eruptions thousands of miles away), can radically alter the late-day coloration of the light, often in ways that can be favorable to the photographer. In addition, indoor light is very different from outdoor light and also varies in type and color.

Sunny vs. Cloudy

These two images of Ajax digging are a good example of the difference in the color of light between sunlit conditions (approximately 5500 K) and the bluer cast of cloud cover.

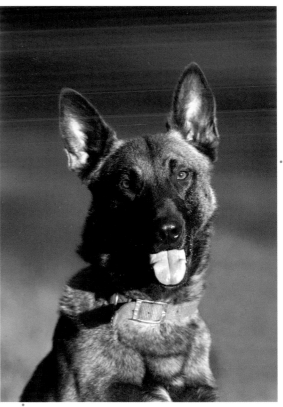

That Late-Afternoon Glow

Late-afternoon light comes from a low angle in the sky, so it must pass through more atmosphere before lighting the subject. The moisture and pollution in this "extra" atmosphere causes the telltale warm color of sunset light.

"Normal" and Daylight

Normal films are daylight-balanced, so they produce neutral, realistic-looking colors in average daylight conditions, like the ones in this image of military training exercises. The auto setting on digital cameras is usually balanced to daylight conditions, as well. Daylight-balanced films are balanced for 5500 degrees Kelvin (5500 K), the "color temperature" of daylight that is equivalent to the color of the light from the midday sun on an average day. If you shoot under these conditions, your film will look neutral and "correct." If clouds cover the sun, the light gets bluish; rain causes it to become even bluer. Like late-afternoon light, early sunlight looks warmer. Before dawn and after sunset the light becomes bluer again.

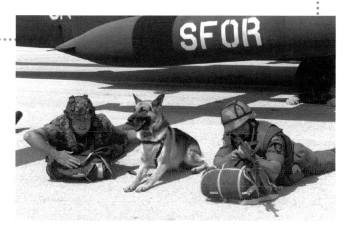

Night Vision

Unless you have a digital camera fitted for "night vision," you won't get a picture like this, but it *illuminates* the point (pun intended!) that there are many types of lighting.

CORRECTING COLOR CASTS

Digital cameras have an auto white-light correction that attempts to neutralize most color casts. Some higher-end cameras give you manual corrections as well as automatic. Check your instruction manual to find out. In some situations, you might prefer the "bad" color cast, such as the extremely warm glow of sunset lighting.

Indoor Lighting

Indoor lighting—like the factory lighting on this U.S. Customs dog—has a very different coloration than daylight, unless the lamps or overhead lights are lit with daylight bulbs (sometimes also called "natural light" bulbs). Film shooters need to use a conversion filter or switch to tungsten-balanced films to avoid an overly yellow image. Digital cameras usually have auto or manual white-light balance, which helps neutralize this color cast.

Indoor fluorescent lighting is one of the most difficult types of lighting because it causes an ugly green cast that's hard to correct. Even with the use of filters, there may still be a slight green cast.

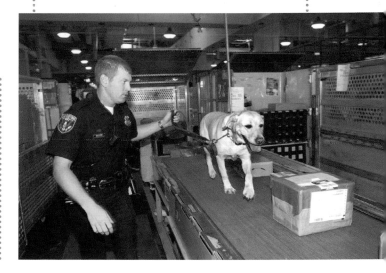

The Quality and Direction of Light

In addition to color, the quality of the light makes a difference in your photos. Direct sunlight, for example, creates dark harsh shadows. This can be great if you want to use graphic shadows as part of your composition, but bad if it turns your dog's eyes into black pits.

Sunlight diffused through clouds is much softer but still directional, and is often good for portraits. Deep shade is the flattest lighting. It's especially good for dogs with coats that have contrasting colors, because it allows you to get details in the highlights and shadows.

In addition, the direction of the light in relation to the camera and subject will impact the look of your picture.

Low-angled light can produce long shadows that can make or break your picture. Noontime light tends to create deep shadows under a dog's chin and turn eyes into black pools unless the head is turned up to or toward the light source. If your dog is positioned so that low-angled sun is to the side (sidelight), you can avoid shadows on the face by having your dog turn its head into the sun (also see page 58).

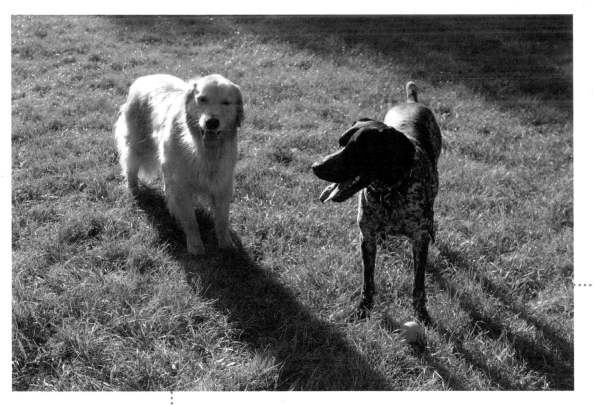

Interesting but Problematic

Low-angled sunlight casts long, graphically interesting shadows and can have a pretty color. However, it can pose exposure problems because of the large difference in brightness between the highlights and the shadows. The contrast between the two is too great for film or digital sensors to capture detail in both.

IT'S ALL IN THE EYES

Dogs' eyes are probably the most important part of any picture you take of them. Where they look is important. Equally important is how the light is affecting them.

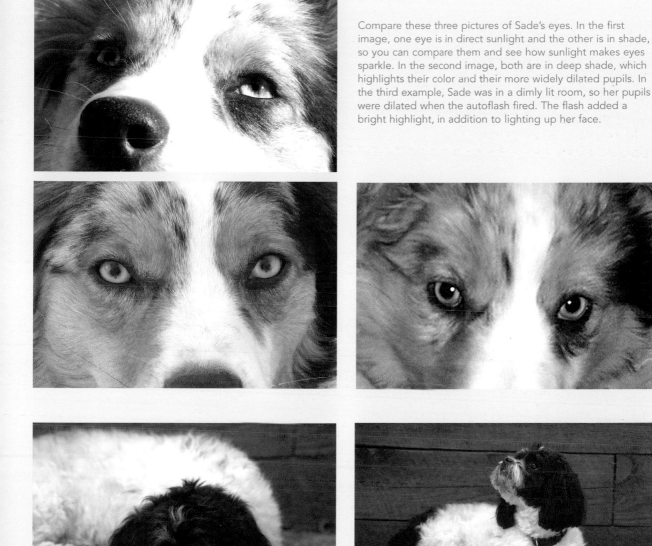

Compare these three pictures of Sade's eyes. In the first image, one eye is in direct sunlight and the other is in shade, so you can compare them and see how sunlight makes eyes sparkle. In the second image, both are in deep shade, which highlights their color and their more widely dilated pupils. In the third example, Sade was in a dimly lit room, so her pupils were dilated when the autoflash fired. The flash added a bright highlight, in addition to lighting up her face.

Heavily overcast skies can make a dog's eyes look flat and dark (left). If you see this happening, you can sometimes pose the dog with its head high so that the light from the sky is reflected in the eyes for a brighter portrait.

Look to the Light

Avoid dark shadows on a dog's face by having the dog turn its head into the light. To get the dog to turn, have someone stand where you want the dog to look and attract the dog's attention. Or, reposition the dog completely to face the light source. If you don't have leeway in positioning, you can overexpose the image slightly so that the shadows lighten up, revealing the dog's eyes (bottom, left).

It's a good technique to walk in a circle around your dog. Look critically to observe how the light and shadow falls. Shoot different variations and compare them. With black dogs, a nice rim light will define the contours of the face and body. Granted, these highlights might be pure white in the photo, but they'll show the shape of the dog in dramatic fashion.

Keep in mind that the classic photo rule *Always Have the Sun at Your Back* has some merit. With the sun behind you, your own shadow will protect the lens from flare, and the front of your subject will be brightly lit, with the shadows falling somewhat behind them. Note, though, that, unfortunately, you'll probably also have a squinting dog; and frontlight may not bring out the texture of the coat and the modeling of the facial structure as well as more directional lighting.

You Don't Have to be Face to Face

Two things are important here: the shadows and the camera position. Time of day (and the height of the sun in the sky) affects the angle of the sun and the resulting cast shadows, so experiment by shooting early, late, and at midday. The long, late-afternoon shadows can be an important part of a picture's design. Though you may not take much notice of them in real life, they will take a bold graphic form in your pictures. Look for the shadows, and make sure they work in the overall design of your photograph. Your dog doesn't always have to be looking at the camera for a good picture.

God . . . sat down for a moment when the dog was finished in order to watch it . . . and to know that it was good, that nothing was lacking, that it could not have been made better.

—Rainer Maria Rilke

Rim Lighting

The position of the sun in relation to your camera can make a vast difference in the lighting on your subject and on the background. Sunlight can come from behind the camera to illuminate the dog or from *behind the dog* to produce rim lighting around a silhouetted figure (below). Neither type of lighting is right or wrong—they're just very different.

Rim lighting can be very effective in some situations. Even though the shadow areas on the dog may be dark and without detail, rim light can emphasize other aspects, like the beautiful texture of a thick, full coat.

All knowledge, the totality of all questions and answers, is contained in the dog.

—Franz Kafka

Silhouettes

Completely backlit subjects can be turned into graphic silhouette images, such as this portrait of a military working dog and his handler. If you base the camera's exposure on the lighter background, the unlit subject will turn black.

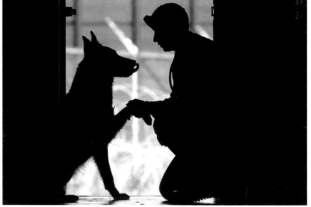

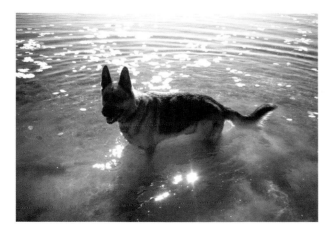

Reflections

Water and other reflective surfaces can play tricks with the direction of the light. While the sun might be coming from one direction, bright highlights can appear in the picture when the light is reflected off the surface of a lake or a car window.

Dappled Sunlight

Dappled sunlight, such as the light under a tree, can cause problems. Our eyes adjust so well to our surroundings that we barely notice it. But the camera sees it as very bright sunlight and considerably darker shade. If a dog's face or body is dappled with random highlights and shadows, it can create a confusing picture. It can also wreak havoc on your exposure, especially with light- or dark-colored dogs.

In general, you should look for shade that is fairly solid, such as under a denser tree or a building. Otherwise, play the waiting game and observe your dog through the viewfinder, waiting until your dog moves into a less dappled area to take the picture.

You want to avoid any awkward patches of light falling in odd places, for example on only the dog's backend here (top). This can destroy the effect of the picture, because the eye is usually drawn to the brightest area in the picture first—and the real emphasis here should have been on the face. Wait until the focal point of the picture is finally in the sunny area (middle).

If you can, position the dog with its face in the sun or the entire body in the shade (or in candids, wait until this happens). The third picture is successful because Tally Ho's face is brightly lit. In a perfect world, the dappling on the back would be eliminated (perhaps by an assistant holding up a piece of cardboard just out of camera view), but it still works overall because of the wonderful light on the face.

Fog

Fog can be quite dramatic and can add a wonderful mood to your photographs. Be aware that this is an especially low-contrast situation, so you may want to bump up the contrast later in photo editing software to achieve richer, lusher results. Heavy fog greatly reduces the contrast, making the picture feel monochromatic. For a foggier effect, use a telephoto lens. This will put more of the atmospheric fog between you and the subject, so the fog will look denser. Move in close with a wide-angle lens for a less foggy effect.

If the weather isn't cooperating, and your camera can take filters, you can place a fog filter in front of the lens for an instant (artificial) fog look.

Lighting for Portraits

The quality of the light affects how flattering your portraits will be. Beautiful, sunny days do not always yield beautiful portraits. Simply moving into the shade makes for softer, more pleasing light and eliminates the need for the dog to squint. Deep shade, however, can be too soft and directionless—resulting in flat, dull images—so you may want to consider livening it up with fill flash (see page 66). When in doubt, try both and compare your results.

Keep in mind that what shows off one dog to advantage might not work as well with another. For example, the long coat of an Irish setter might look great in bright sunlight, because the shadowing brings out the texture of the wavy coat. However, a chocolate Labrador retriever might have a shiny, reflective coat that causes burned out (white) highlights without details. Experimentation is crucial to mastering your photography.

Sunny vs. Shady

Sunlit portraits bring out vivid color and are a good choice when a dog's face is not in shadow. Shady or heavily overcast skies give a softer effect that usually yields pleasant portraits.

Indoors

The simplest light for indoor photography has been used for centuries: northern window light. The old master painters all had windows in their studios that gave them northern light. Northern light creates wonderful diffused lighting all year round. By changing your camera angle and the dog's position in relation to the window, you can get great control over the direction and quality of the light. If you don't have any north-facing windows, you can put sheer white curtains (without stripes or patterns) over windows that get direct sunlight. The curtains work like diffusion material to soften the harsh sunlight.

USING REFLECTORS

Harsh sunlight casts dark, hard-edged shadows and creates a high-contrast image. Film and digital cameras have a limited contrast range and can't always provide detail in very darkly shadowed areas and brightly highlighted areas—especially on multicolored dogs. If the contrast can be reduced, then the camera can record details in both. To do this, place a reflector in a position opposite the angle of the sun so that it bounces some of the light back at the shadowed side of the subject. This lightens (fills) the shadows so that the overall contrast is reduced. You don't need a high-end SLR camera to reap the rewards of reflectors and diffusers. They can be used to improve pictures with any camera.

Reflectors can be made from construction board, poster board, mat board, or cardboard. Shiny metallic surfaces reflect back a harsher, brighter light, though gold adds warm sunset tones. Crumpled tinfoil can be taped over cardboard to create a reflector that adds bright fill light. Larger reflectors let you modify larger subjects, but even the collapsible type can be bulky. Beware: In windy conditions, larger reflectors become bigger sails!

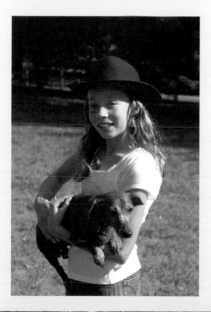

Without a reflector, the direct sunlight produced deep dark shadows both on the girl and the dachshund (left). However, a white reflector held nearby bounced the sunlight back toward the shadowed side of the subjects. This lightened the shadows for a more pleasing portrait.

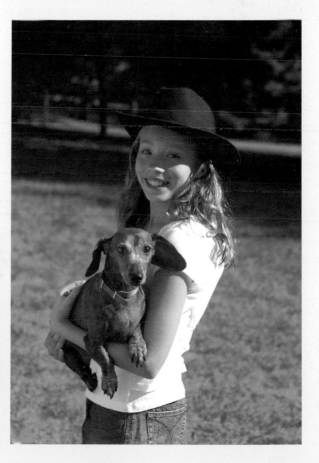

Flash

Most people think they should use flash only in dim lighting. However, used in a controlled way, your camera's flash can be an important creative tool. Most cameras today have a built-in flash. It can be a flash that you must manually pop up or otherwise activate, or one that fires automatically when needed. Higher-end cameras often have several flash modes that allow you to customize the operation of the flash for optimum results under different lighting situations.

Most on-camera flash units have trouble illuminating super-wide-angle views, because they don't provide wide enough coverage to light the whole subject. Using an off-camera flash helps avoid this.

Autoflash

The default flash mode in your camera is called Autoflash. Usually, the flash fires when the camera thinks it's needed because the lighting is dim relative to the film you're using. Instead of switching to a slow shutter speed, the camera fires the flash. The Autoflash on your camera is designed to produce nice illumination on subjects that are an average portrait distance from your camera—usually five to twelve feet or so.

Autoflash can light up a dusk snowball fight nicely, for example. Snowflakes that fall between the subject and camera are illuminated by the flash and emphasize the snowstorm effect.

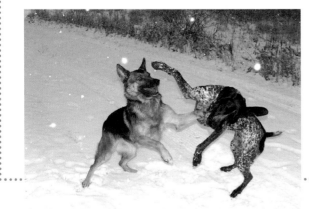

Autoflash Limitations

In many situations, Autoflash mode delivers a good result. However, sometimes when the flash fires, the background in the captured image turns black. This happens because the flash is combined with a narrow aperture and a fairly fast shutter speed—so, there's enough time for the relatively powerful and instantaneous flash to record on film, but not enough time for the dimmer surrounding ambient (existing) light to record. With more sophisticated flash programs, such as Night or Slow-Sync flash, the camera balances the background light with the flash illumination so that both record on film during a long exposure.

Another major shortcoming of built-in flash is the power of the unit. Even with fresh batteries, built-in flash units have a very short range. Check your instruction manual to find out how far you can be from your subject and still have a reasonable expectation that the image will be properly exposed. For some cameras this might be less than ten feet with ISO 100. If your subject is beyond the distance range of the camera's flash, the result will be an underexposed image. The same will be true if your batteries are weak.

Other problems include flash fall-off and burn-out. Fall-off occurs if you're using a lens that sees a wider angle of view than the flash can cover. You may get dark outer edges where the flash cannot reach. On the flip side, being too close to your subject can cause flash burn-out—the flash cannot reduce its power enough and, therefore, overexposes the subject. You can also get burn-out if a foreground element, such as a tree branch or even a snow flake, is in the path of the flash. The result will be a glaring white or bright spot in the foreground.

Flash exposure compensation gives more control. It allows you to under- or over-expose the flash portion of the image. Photographers often select -1.0 EV flash exposure for filling shadows (fill flash) on bright, sunny days (see page 68).

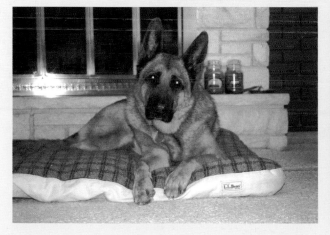

Reflective objects, like the fireplace behind Trucker, can become distracting white highlights in pictures taken with flash.

On some SLR cameras, you can select a shutter speed that's too fast when you're using flash, which results in a portion of the image turning black (because the shutter itself blocks it).

Fill Flash

One of the most useful flash modes is Fill Flash, which is designed to be used when part of a nearby subject is in deep shadow. On bright sunny days, the fill flash can lighten the dark shadows caused by direct sunlight so that you can still see detail. However, unlike the Autoflash mode, Fill Flash mode should provide less exposure than the sun. In this way, your photograph still looks sunlit and natural—only better because there are no black shadows on the subject, and there's probably a pretty highlight from the flash in the dog's eye.

On most cameras, the Fill Flash illumination is set at about one stop less exposure than the existing light, so it won't overpower the existing sunlight. Some higher-end point-and-shoots and SLR cameras enable you to adjust the power of the fill so that it's stronger or weaker. This gives the photographer a lot of control. Weaker fill is subtle and almost undetectable to the untrained eye, while stronger fill makes the subject pop out from the more distant background.

If your camera doesn't offer Fill Flash mode, you can use Force Flash mode as an alternative. Force Flash mode fires the flash regardless of the lighting situation or the film in use. It's similar to Fill Flash, but instead of just filling the shadows, Force Flash becomes the main light. Be aware that the flash will be at full exposure and, therefore, may overpower the existing light. It may also cause the background to look darker in the final image, similar to an Autoflash effect.

Fill flash eliminates harsh shadows, softening the look of the subject, and allows more detail to be recorded.

Catchlights

A more subtle use of fill flash is to add catchlights in the eyes, even in overcast situations.

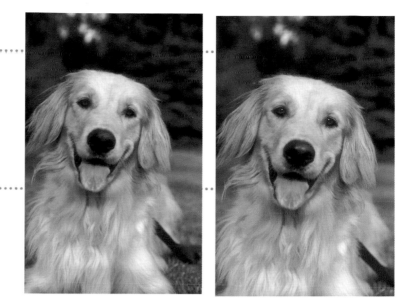

RED-EYE, GREEN-EYE

A common problem that arises with built-in flash is the red-eye phenomenon, except with dogs, it often shows up as a greenish/ yellow eye color. Some dogs seem more prone to this problem than others.

Green-eye is most likely to occur when the flash is close to the lens and, therefore, on almost the same axis with it, allowing the flash to bounce off the retina of the eye, which appears green in the final image. One of the advantages of SLR cameras with accessory flash units is that the flash is ralsed up and far away from the lens axis, eliminating this problem completely.

You can reduced the red-eye effect with Red-Eye Reduction flash mode, which is usually indicated on the camera by an eye symbol or an eye-and-lightning-bolt symbol. Different cameras handle red-eye reduction in different ways; the most common is to fire a series of pre-flashes or shine a very bright lamp at the subject to close down the iris so that less of the flash illumination can bounce off the back of the eye. This does not always completely eliminate the problem, but it does reduce it.

The downside is that a pre-flash or a lamp can cause a delay in the firing of the shutter; in other words, you can miss the moment. Also, some dogs react negatively to the bright lights, so sometimes you avoid the red-eye but get an unflattering, startled expression in its place—or the dog disappears behind the couch. (See appendix A for hints on photographing camera-wary or camera-fearful dogs.)

Other Flash Options

Flash Off Mode

Autoflash mode on most cameras means that the flash will automatically fire if the camera thinks it is needed. (This is not the case if you must manually pop up your flash before using it.) The problem is that in any low-light situation, the camera will automatically fire the flash. This usually overpowers the existing light, and the result is a flash-illuminated subject. As mentioned previously, if the background is distant, it will often go black.

However, many times the "dim" light is perfect for portraits because it's beautiful in color, direction, or quality—and it is still enough light for you to get a sharp photograph if you steady the camera and/or switch to a faster film/equivalent ISO. You don't want to "wreck" the light with glaring flash illumination. In these situations, you can turn the Autoflash off by putting the camera in Flash Off mode, which is most often represented by a lightning bolt symbol with a slash running through it. Excellent examples of light for which Flash Off mode is best include late-afternoon sunlight, twilight, dawn, and the soft light from a north-facing window.

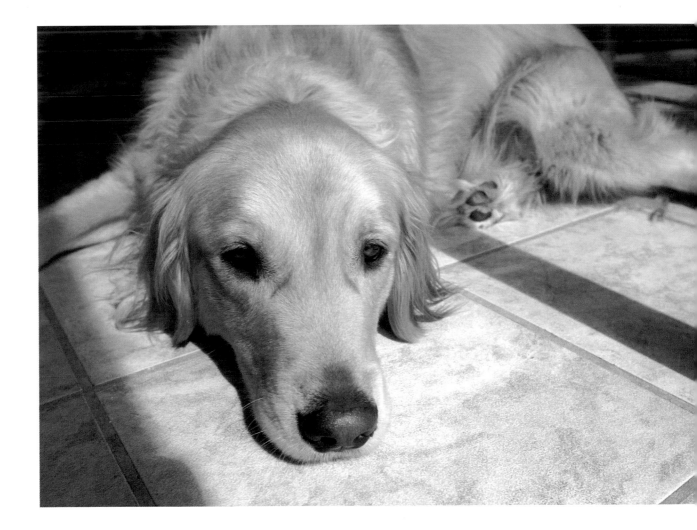

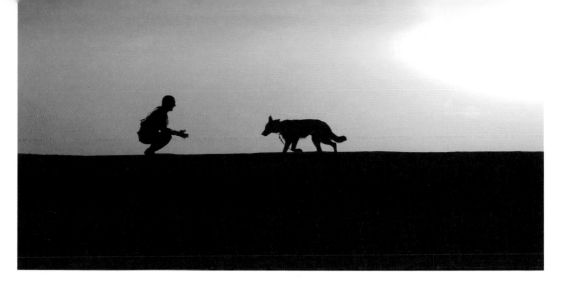

Flash Off (for Silhouettes)

Silhouettes at sunset or pictures of shadows also require Flash Off mode. The subject is the darkness itself, and you don't want to light it with flash. But the camera might want to fire the flash even though the subject is far beyond its reach. This can result in drastic underexposure. Likewise, the camera might want to fire the flash if you're shooting an indoor dog show from the spectator seats, for example. But your flash is too weak to light a whole arena, so the pictures would be underexposed. In this situation, turn the flash off.

Slow Sync Flash

A few cameras offer a flash mode that's sometimes called Night Flash or Slow Sync flash. The symbol is usually a lightning bolt combined with the word "slow" or a symbol of a moon and star. In this mode, the flash is combined with a slow shutter speed. The dimmer natural or existing light can be recorded during the long exposure, while the powerful flash instantaneously lights a nearby subject. You could, for example, use this mode to take a picture of a dog at sunset or near a bonfire. Just be careful that your dog is within the distance range of your flash; otherwise, the picture will be underexposed. And note, however, that any time you mix flash with a long exposure and moving elements, you risk getting ghosting (partial blurring) in your images, as in the detail at left.

Accessory Flash

A built-in flash can be a big help, but it is weak and limited compared to the accessory units you can add to most SLR cameras. These offer greater power and range, and a reduction in red- or green-eye. Usually, the accessory flash is attached to what is called the *hotshoe* on the top of the SLR, but it can be moved off-camera (via cable or wireless transmission) for more directional lighting. Most accessory flash units can be tilted for additional effects. When pointed straight up, they can be bounced of a ceiling or an attached reflector card for softer lighting.

An accessory flash that's dedicated to your camera system is the best, because it works with the camera's on-board computer to coordinate exposure, shutter speeds, and flash output. When some high-end accessory flash units are combined with high-end cameras, they offer advanced capabilities, such as the sending out an undetectable pre-burst to test the distance of the subject for precise autofocusing in the dark or to test reflectivity for proper exposure of especially light or dark dogs.

Other advanced capabilities include flash exposure compensation, multiple-flash synchronization, close-up (macro) photography, stroboscopic effects, and rear-curtain flash, which is especially useful for shooting moving subjects at night.

CREATIVE CANINES
Composition

4

How you compose your picture is the most important aspect in creating a great photograph. And good compositions can be made with any camera—even a $5.00 disposable model! That's because it's more about artistry than technical considerations. What you decide to include in the picture, the angle you shoot from, or how you coax your dog can all make a huge difference.

The Rule of Thirds

The Rule of Thirds is a compositional aid that helps you create balanced, successful photographs. The vast majority of great photographs (and great paintings) follow this rule or take it to even further extremes, so it has truly stood the test of time.

To start, imagine a grid in your viewfinder that divides the frame into nine equal sections. The four points where the two horizontal and two vertical lines intersect become the most important "real estate" in the image. The lines themselves are the second most important part. Your goal is to place your important picture elements at the intersection points or, at the very least, along the lines. Horizon lines work well if they're placed to coincide with the top or bottom horizontal line, and they can often be successfully pushed even higher or lower for creative purposes.

At first, you'll have to work at designing your photographs to the fit the Rule of Thirds, but soon it will become second nature and almost instinctual. In fact, if you go back and review favorite pictures that you took before you understood the Rule of Thirds, you'll probably find that they fall into this pattern.

The Rule of Thirds is very flexible and works equally well for horizontal and vertical images, and for panoramic and square images. Be careful however: Most cameras have center-weighted autofocus, and will therefore try to focus on whatever is in the bull's-eye of the frame. Use your camera's focus-lock function when shooting off-centered subjects, depressing the shutter halfway and then recomposing (see page 12).

Using the Rule of Thirds as a basic compositional guideline to place your subject, the horizon line, and other picture elements off center results in better design.

It's All in the Eyes

The eyes are the most important element in a portrait, so they should be placed off center, rather than in a bull's-eye position. This also serves to leave less blank space above the subject's head.

Eyes centered—too low in frame **Eyes on top third line—just right**

BREAKING THE RULE

You may also want to push the rule to an extreme and place the objects further toward the outside of the frame. This often works, especially with wide-angle images.

Occasionally, you'll want to break the Rule of Thirds by centering the main subject, but keep in mind that this rarely works, because the more you move your subject and other picture elements toward the center of the frame, the more static and lifeless the image becomes.

Here, the two key picture elements (the search-and-rescue dog's face and the New York Fire Department logo) are placed higher and lower than the upper and lower one-third positions.

The Horizon Line

Even if you can't see the horizon, its placement is vital to your picture. We instinctively want to know what's up and what's down, and we reference it by the place where the land meets the sky. In some pictures, the horizon is visible; in others, it's implied.

The first horizon line rule is to keep the line straight, unless you have made a conscious design decision to tilt it. If you accidentally shoot a photograph crooked, you can rotate it later in the computer, but some of the outer edges of the image will be lost.

The second horizon line rule is to avoid bisecting the picture with the horizon. A centered horizon line creates a static composition. The only appropriate time to center it is when you want to create a feeling of stillness. In most situations, it's best to push the horizon line (or the implied horizon line) into the upper or lower third of the frame. Evaluate the sky and the foreground, and then decide which is more important from both a design and a storytelling viewpoint.

Here the horizon is placed approximately one-third from the top of the picture, and it does not intersect with the subject. The important part of the image is the strolling couple in the foreground, so pushing the horizon line upward to the top one-third position was the appropriate decision.

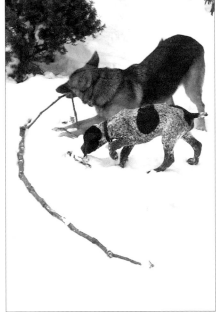

Other Lines

The horizon line is usually the most obvious line in your pictures, but it's not the only important line in photographic design. Leading lines can focus the viewer on important compositional elements in a picture. Diagonal and wavy lines tend to make a picture seem more dynamic and often imply motion. Straight horizontal and vertical lines are inherently static, evoking words like *strength* and *stoic*, and help anchor a composition. Wavy or curving lines imply motion even more than diagonals. They make almost any picture seem livelier because they lead the eye around the composition. The best curving lines eventually point toward the subject (right).

Some photos make use of more than one type of line: The running dogs create a strong diagonal line, while the upright trees anchor the picture (opposite, bottom).

Bad Lines

Not all lines are good. Straight vertical or horizontal lines can sometimes be too static, resulting in a boring composition. Likewise, lines that go through your subject awkwardly can be very distracting. This ranges from the horizon line going behind your dog's face (top left) to a tree growing out of her head. If the subject merges too much with the background elements, this can make the subject difficult to "read" and can result in an unsuccessful photograph. Simply moving to the side or raising or lowering your shooting angle can fix the problem (bottom left).

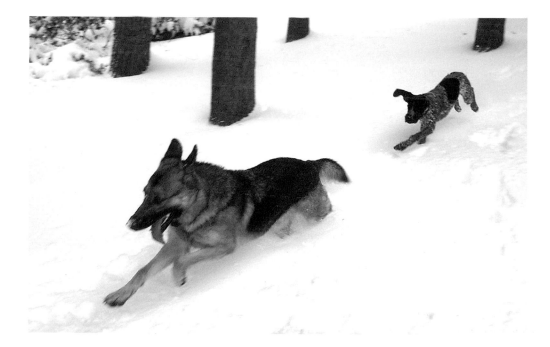

Direction and Simplification

Into the Frame

Even when you have a single subject and interaction is not an issue, the direction of your subject's gaze is critical. Always make sure your subjects are positioned so that they look or face toward the center of the frame rather than toward an outer edge. If they're on the right side of the frame and looking to the right, the result will most likely be very disconcerting.

With action photographs, *always* try to leave visual room in the composition for the subject to "move into." Rather than centering the image, leave more space on the side toward which the dog is moving. The result will be a much more balanced and less cramped-looking composition.

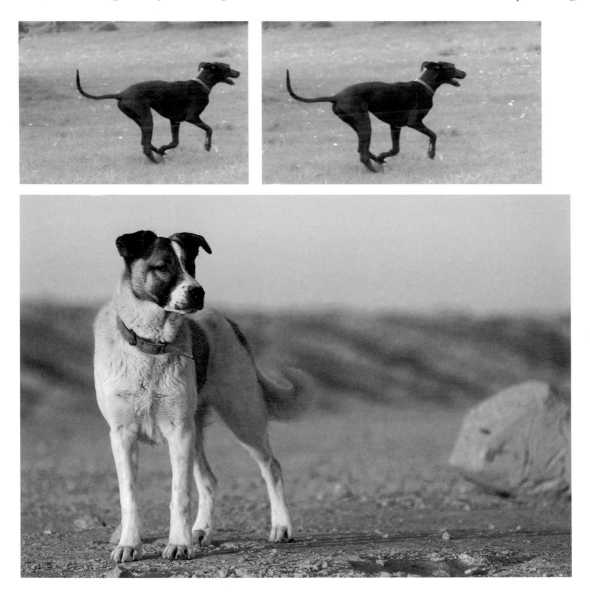

In addition to the dog's head and gaze being directed toward the center of the frame, this image does several other things right: The horizon line is placed at the upper third line. The dog is off center in the left third of the frame. And, the photographer chose a very low vantage point (even lower than the dog's eye level), which gives the subject a regal presence. In addition, the warm colors of the desert light lend a wonderful mood to the entire image.

Simple but Not Easy

It goes against logic, but often the simplest pictures are the most difficult to take. More often than not, you are confronted with a scene that has too much "stuff" in it, too many scattered picture elements that would compete for attention. Your goal is to determine a hierarchy among all the picture elements: Which are important? Which are visually pleasing/interesting? Which are unimportant? Which are distracting? Large, bright, colorful, or symbolic elements (such as a flag or an object that could evoke a idea or feeling) tend to be the most distracting.

There are several easy ways to simplify your images. If your background and foreground don't add to the story, then zoom in or step closer to your main subject, cropping out more of the background and foreground. Then, try to use the camera angle and lens to separate important picture elements from the background and from other elements. Reposition the dog if there's a billboard, other sign, colorful object, pedestrian, car, or patch of sunlit tree behind the dog. Just squatting down or moving to one side a little can often change the angle enough to improve the background. Alternately, use shallow depth of field (see pages 40 and 42) to throw the background out of focus, thereby reducing its effect.

The buildings and sky in the background add nothing to the "story" of this image. The image is much stronger when those elements are cropped out.

Turn Your Camera: Vertical vs. Horizontal

• •

Amazingly, rotating the camera ninety degrees is one of the easiest ways to simplify an image. Just opting for a vertical composition can make a huge difference, because you can often better fill the frame with a vertical subject. Switching to vertical can crop out extraneous (and unimportant) background picture elements. Vertical compositions are especially useful for head-and-shoulder shots of your dog, or for a portrait of a dog and a person, or for any subjects that are taller than they are wide. Verticals allow you to fill more of the frame with the subject, making your subject larger in the final image and usually improving the composition.

Beginning photographers often forget that they can turn the camera sideways. It may sound silly, but when you first start, you must ask yourself, Is this a vertical or a horizontal picture?—before you press the shutter.

Foreground and Background

When shooting portraits, you may spend a lot of effort eliminating distracting foreground and background elements, leaving only the all-important subject in the mid-ground area. However, for many types of photographs, balancing interesting elements in the foreground, mid-ground, and background can make a very powerful image. For example, you'll almost always see at least two strong picture elements in great landscape pictures.

To make artistic pictures of your dog, consider objects in your images, and try to see if they improve the picture. If all the elements are dominant in size and color, the result will be a confusing competition between them, and the image will seem to lack a single main subject. Consciously pick your main subject (probably your dog) and then "wrap" it with one or two other minor subjects. Preferably, these minor subjects will not be on the same plane—that is, they will be in the foreground and background if the subject is in the mid-ground.

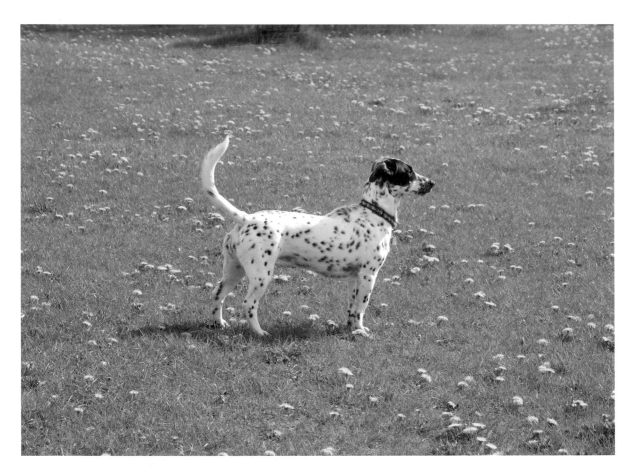

The field filled with bright yellow dandelions is certainly a pretty background (and foreground). The yellow color accents also brighten the picture and serve as a humorous reflection of Pyper's spots, as if the world is as polka-dotted as the dog.

The main subject of this picture is clearly the puppy about to initiate a play session with a German shepherd. However, without showing the foreground dog, it would be a boring picture. Emphasis is kept on the puppy, however, by using shallow depth of field to throw the German shepherd out of focus.

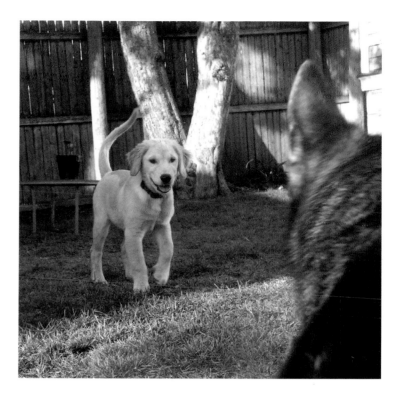

Dachshunds are ideal dogs for small children, as they are already stretched and pulled to such a length that the child cannot do much harm one way or the other.

— Robert Benchley

f/22 yields greater, more distracting depth of field

f/2.8 yields shallower, less distracting depth of field

Background Considerations

Aside from poorly placed horizon lines and awkward lines and mergers, there are also several other background distractions that can cause you problems. Bright colors or bright highlights and reflections can confuse the picture, since our eyes are naturally drawn to the brightest or most colorful things first. As with other distracting elements, either crop them out (move closer, zoom closer, change lenses); change your position (right, left, higher, lower); move your dog; or switch your aperture to use depth of field to throw them out of focus.

Framing

One of the most powerful compositional techniques is to create a "frame" around your main subject using other elements in the scene. The framing element surrounds the subject the way a picture frame surrounds a photograph or painting. Unlike a picture frame, however, this frame need not completely enclose the subject. More commonly, it will relate to part of the subject. Either way, its purpose is to force the viewer's eye deeper into the composition, toward the main subject.

Keep In Mind . . .

When designing your frame, try to avoid cutting off the silhouette of your main subject, because doing that defeats the purpose. A higher or lower shooting angle or a different focal length lens may do the trick. Take special care that a foreground frame is not more interesting than the main subject. If it is, abandon the concept of a frame, and find a different way to bring the focus onto your subject. Remember, the goal of the frame is to bring the viewer's eye in toward the main subject first, and then later to the framing element.

A concrete tunnel on an agility course can become an interesting frame for a creative photographer.

Adorable Sade plays peek-a-boo through the trees, which serve to frame her face.

Color: It's Not Just about the Fur

Most people get caught up in the color of their dog's coat and forget about the color of other objects in the scene. But where and how you use color in your compositions can have a significant impact on your final pictures. One major reason is that certain colors are associated with moods and feelings: Blue tones often evoke words like *cool*, *refreshing*, and *melancholy*. Reds evoke words like *warm* and *sporty*.

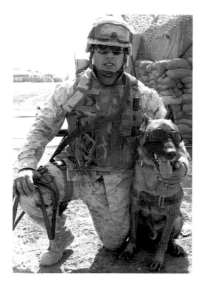

Symbolism and Accents

Colors can be heavily shrouded in symbolism, for example in the way that Americans associate red, white, and blue with patriotism. Likewise, certain colors or color schemes are often associated with particular holidays, such as red and green for Christmas or orange for Halloween.

Color is very powerful. This is why it can function as an accent in a picture when used with prudence. For example, a bright red bandana or collar can help focus the viewer's attention in a dog portrait taken in an otherwise busy environment. Keep in mind, though, that it can be very distracting, especially in the background, if it does not relate to the subject.

The red sunglasses worn by both the dog and the handler provide a nice color accent that unites the two.

Bright reflective orange, red, and yellow are colors symbolizing and worn by fire departments and rescue units everywhere.

Abstraction and Symmetry

Not every picture has to be an obvious portrait of your dog. You can have some fun using more abstract elements, such as pattern, shadow, and symmetry. And though an image does not really show the dog, it can still show the spirit of the dog. Patterns and symmetry are graphically interesting. But they also help unify two subjects on an unconscious level—if they match visually, they match symbolically.

With only its nose showing above high weeds, this search-and-rescue dog looks like a shark skimming the surface of the water. Other than the silhouette of the nose and ears, you're seeing very little of the dog—yet the overall effect tells you a lot about the animal.

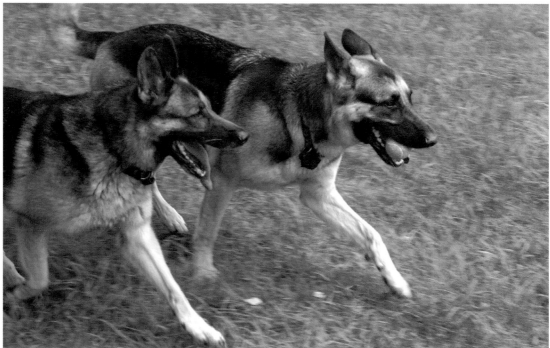

The matched strides of these two German shepherds creates a nice symmetrical repetition that unifies the composition, creates an implied bond, and seems to emphasize their brother and sister relationship.

The symmetry of the bus windows in this photograph of a hurricane evacuee gives graphic structure to the picture. It also emphasizes the link between dog and owner, because they become two halves of a pattern.

TELL A STORY

● ●

The old saying *a picture is worth a thousand words* only holds true if your images tell stories. Portraits are portraits, but often, you're going to want more. The easiest way is to show your dog in its environment. Pictures of your dogs interacting with one another tell the story of pack life in your household. Slice-of-life pictures that capture the antics and personality of your dog will probably become your favorites—and be the strongest images in your album.

Storytelling is not easy, however. You may get lucky once in a while, by accident, and end up with a thousand-word picture. But good storytelling takes a conscious effort. Think about what you want to "say," and then look for the picture elements that will communicate it. For example, you might have lots of portraits of your Chihuahua and lots of portraits of your Great Dane. In some of the pictures they may even be together. But how do you really tell the story of their vast size difference? An image of your Chihuahua dwarfed by the legs of a great Dane might do the trick.

I wanted to tell the story of the difference between wolves and dogs. How could I do it in *one* picture? My best solution was to show a black German shepherd puppy meeting its wild cousins through the fence of a containment cage at a rehabilitation center. The cage showed the great gulf between the two. It also showcased the sad irony that the wild wolf was caged and contained, while the collared domestic dog was free to roam.

Get Down! . . . and Up

Camera position is another important aspect of composition. How high or low an angle you shoot at, combined with the lens setting you select, will dramatically impact your pictures.

See Eye to Eye

By far, the quickest and easiest way to improve your dog pictures is to get down on your dog's level. Not only is the low angle more intimate in feeling, but it causes less optical distortion. We commonly shoot pictures of people at their eye level because we're relatively the same height as our subjects. But few pets are as tall as we are—unless your Irish wolfhound is standing on its hind legs! Your dog's eye level may be at your hip, knee, or even ankle.

Getting to the eye level of a Chihuahua may mean stooping down considerably more than you would have to for a Great Dane, but you can quickly improve your pictures if you get to your dog's eye level.

Really Low Down

Dropping down to below eye level, so that you're actually looking up at your dog, can give your photographs an artistic flair if you do it prudently. In classic human portraiture, men are often photographed from slightly lower than eye level, making them seem taller and more powerful; it's considered a "masculine" camera angle. The same holds true in dog photography. The extra-low angle also provides an unusual view of the world—perhaps how the family cat sees the dog most of them time!

Get Up

Camera angles that are higher than your subject can provide an interesting effect, as well. In the case of seated people, looking down at them is usually not the best portraiture technique because it causes distortion. However, it's a valid technique when done to produce a better background (the camera now sees the ground behind the subject, rather than a distracting background). A higher-than-normal camera angle can also give an eagle-eye view of scene. And, even though you are breaking the eye-level rule, you can still get an intimate portrait with a simple background.

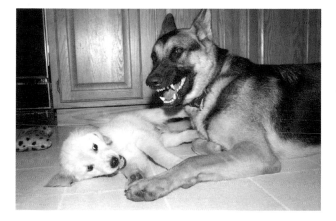

When two dogs are playing, you can usually position yourself so that both are clearly visible when you're at their eye level (left). However, if the action gets too horizontal, the only good composition might be a top view (below), since the eye level view might show only paws and ears.

Understanding Perspective

As mentioned previously, focal length can change your composition as you zoom or change your lens. But for the most part, aside from a little lens distortion, when you zoom from wide to telephoto (from a lower focal length number to a higher focal length number), you're just cropping the image. In other words, you're magnifying the centermost part of the image, as if looking through a pair of binoculars. To make a *perspective* change, however, you actually have to change your camera position in relation to the subject. Spend some time playing with your focal lengths (go from Wide to Tele and back again) and your camera position, to experiment with the effect perspective can have on your photographs.

Make a Move

Your distance to your subject, combined with your lens setting, can make a drastic difference in the persepctive and, therefore, the look of your photograph. In the example here, the subject position did not change—they got no closer or farther away from the fence and white building in the background. But I moved: I was fairly close with a wide-angle lens setting for the first image (above). Then I walked quite a distance away until the girl was about the same size in my viewfinder with a telephoto lens (left). This altered the perspective—which is most notable in the relative change in size of the distant barn—and changed the composition completely.

Getting to your dog's eye level in combination with adjusting your distance to your subject and your lens selection can have a radical effect on your dog portraiture. Here, shooting from a high camera angle causes the dog to look up at the photographer, producing a distorted, big-head look that makes the dog look puppyish (top, left). Getting down closer to eye level, but in close with a wide-angle lens, causes distortion, as well (top, right). Being at true eye level, but moving back and using a telephoto lens (above), provides the most classic rendition.

Close and Wide/Close and Tele

Close and Wide

Moving in to your camera's minimum focusing distance with the wide-angle lens setting or a wide-angle lens on an SLR camera can produce a big-nosed, goofy result or a dramatic, in-your-face picture. With super-wide angle lenses, such as 15mm or 18mm, you can create a lot of image distortion. A normal to wide-angle lens setting, such as 35mm or 45mm, will still cause some distortion.

An up-close and wide-angle composition makes Parker, a Weimaraner, look as goofy as he sometimes acts.

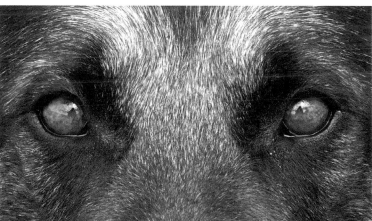

Close and Tele

You can also move in close to your subject with your Telephoto lens setting or a 100mm, 200mm, or longer lens on an SLR camera to create frame-filling pictures. Here, you'll be working from a further distance, which is sometimes easier because it's less distracting to the dog. You'll also avoid the wide-angle optical distortion.

A telephoto lens allows you to take a frame-filling portrait from several feet (or even yards) away. Some telephoto lenses, including macro lenses, have short minimum focusing distances, so you can take an up-close look at the dog. The distance to subject in the example above was about five feet, which filled the frame with just eyes.

How close and frame-filling your image will be depends on your focal length (higher number focal lengths produce more magnified, "binocular" effects) and your distance from the subject. You may not be able to get as close as you'd like with some lenses, because of the lens's minimum focusing distance. Macro lenses, close-up lens attachments, or the Close Up mode, enable you to focus closer than normal to your subject.

Far and Wide/Far and Tele

Far and Wide

Most scenic landscape photography is taken with a wide-angle lens, to capture a sweeping view of the environment. You can also use this technique when you want to show an animal in its environment. I wanted to show the high level of obedience and agility training that search-and-rescue dog Panda has (right), so I used a wide-angle lens and stepped away from him. This showed him within the environment.

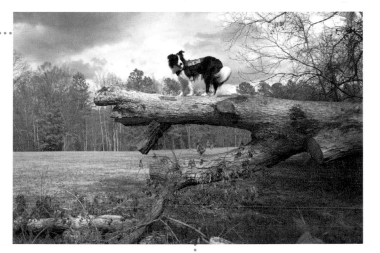

Far and Tele

You can also capture distant subjects using the Tele (T) setting on a point-and-shoot zoom camera or by switching to a telephoto lens (or adding a teleconverter) on your SLR camera. Action at a distance, such as dogs on a coursing race or two dogs playing, can be photographed at a safe distance with a long focal length lens, such as 200mm or 300mm. Candid photography, taken surreptitiously, like a spy, is a good candidate for a telephoto, as well, because you can shoot from a discreet distance. Telephoto lenses let you shoot frame-filling pictures from a great distance away.

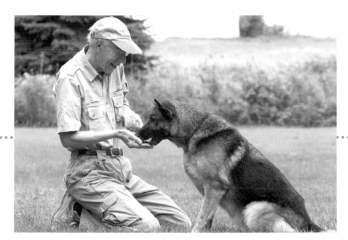

PUPPY LOVE
Puppies

5

Who doesn't love a puppy? Puppies are both the easiest and the hardest to photograph. It's not surprising. They're just so cute, and they do the silliest things. Who could take a bad picture? But then again, they are moving targets, untrained and totally erratic—so it's not that easy. And just try keeping them far enough away from your camera to get an in-focus picture!

Hound Your Pup

Puppies have seemingly boundless energy. If you shoot only a handful of pictures during all this activity, you'll probably get lucky once or twice—and then have a lot of blurry and out-of-focus throwaway shots. Instead, keep shooting! Your timing will improve, and eventually, the pups will tire out. You'll also "settle down" yourself and start thinking about angles, lenses, backgrounds, and more—and that's when you'll get your real winners.

Puparazzi

The more pictures you shoot, the more likely you are to get some keepers. And, while you keep shooting, don't forget to zoom your lens in all the commotion: Wide angles are good when the little tykes are close to you (above), but as mentioned previously, telephoto lens settings offer the best "classic portraiture" look (above, right). Also, experiment with points of view: A low-angle view shows off puppy personality more so than a "high altitude" shot from standing height, which shows the pups from more of a distance (opposite, bottom).

Keep in mind that precious moments are hard to capture because the action usually happens so fast that the moment is gone before you can raise your camera. So, always have your camera ready during play sessions. If your camera shuts off automatically or goes into Power Save mode if unused for a certain amount of time, tap the shutter button lightly every minute to prevent this from happening; restarting the camera can take too much time.

FYI: GET DOWN ON THE GROUND

It might be safe to put full grown medium- or large-sized dogs on a table to photograph them, but puppies could seriously injure themselves if they fell or jumped. Instead, get down on their level for the most engaging pictures—this may mean on your belly, on the ground.

Dog Tired

After a play session, when puppies run out of steam, they often sleep deeply. You can usually pick them up and pose them without disturbing their slumbers. Try placing them in cute or interesting configurations for adorable shots.

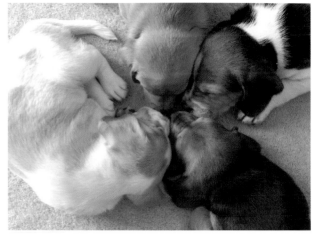

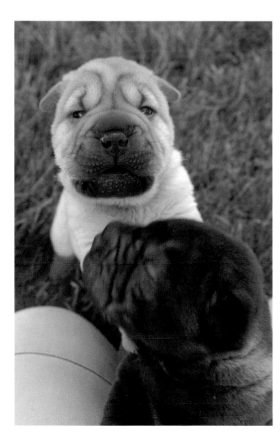

Cropping for Moving Targets

Puppies have a short attention span and tend to play in spurts. With a high equivalent ISO setting you can get action-stopping pictures, while in lower light conditions, consider panning for creative blur.

If the puppies are moving around too quickly for you to get a perfect composition, you can always make improvements later through cropping.

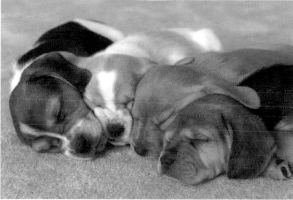

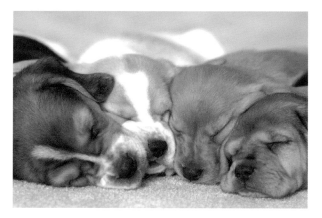

GET HELP

● ●

Puppies love to investigate and play. A prone photographer is just too good a target, and you will miss many great shots because the puppies approach your camera too quickly to focus or they get so close that you can't focus on them because of the minimum focusing capability of the lens. A "puppy wrangler" will really help—and it's not hard to get volunteers for this job. Simply have your wrangler pick up the puppy and place it where you want, over and over and over again. Your wrangler can also warn you when a puppy other than the one you're photographing gets dangerously underfoot or decides that your camera bag is very interesting. Assistants should be nimble footed, because it's not an easy task to keep the puppies herded and stay out of the picture at the same time.

Kids, Pups, and Props

Child's Best Friend

There's nothing cuter than a photograph of your kids with puppies. Juveniles with juveniles is always a good photo theme! Even if you don't have children, a photo session with a neighbor's children is a good way to socialize your puppies so that they won't be afraid of kids when they grow up. Children love puppies, so it's not hard to find willing participants. However, children need to learn that puppies aren't like adult dogs, in the sense that they need special handling. Teach kids that they can't roughhouse with puppies too much. Show them ways to hold a puppy that are safe and photogenic. They also need to reinforce rules, like not letting puppies put their teeth on people's hands, because puppies must learn bite inhibition. Children shouldn't put puppies on chairs or tables, because they could fall and be injured or killed. And most of all, kids must not terrify the puppies. The play should be comfortable for both the canine and human participants, or the dog might grow up to be fearful of children.

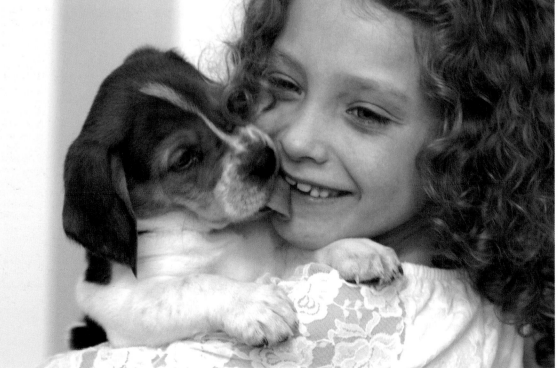

Give a Dog a Bone

Visit your local dollar or thrift store to look for cute props. Wicker baskets, silk flowers, fuzzy slippers, squeaker toys, giant shoes, summer hats, plant pots, or even a little red wagon are all great props. Items that contain the puppies will make your job easier because they keep the pups in place while you photograph them. Also consider choosing a prop that you can use as a size reference to show the puppy's growth over time, as in these two images of Gridley with a plant pot at eight weeks old and then older.

And if your dog hasn't "met" a mirror yet, get your camera ready and place one on the ground. Gordon, below, play-bows to his "new friend."

SICK AS A DOG

• •

It's a good idea to read a book on puppies before doing any serious photo shoots. If they're your own family's puppies, you've probably already done this; but if you're shooting a friend's dogs, it's good to know about the different life stages. For example, you'll need to watch puppies carefully if you're working outside in even moderately hot or cold situations, because young puppies can't regulate their own body heat well. Watch for signs of hypothermia and overheating. Keep the shoots extremely short in these conditions. In colder weather, consider keeping the pups contained to an electric whelping pad, which is set to dog body temperature (about 102 degrees F).

If you're visiting a friend's puppies, make sure your dogs have had all their vaccinations and have been wormed—even if you're not bringing them along. It would be a terrible shame if you accidentally tracked in viruses, diseases, or larvae on your shoes, clothes, or hands.

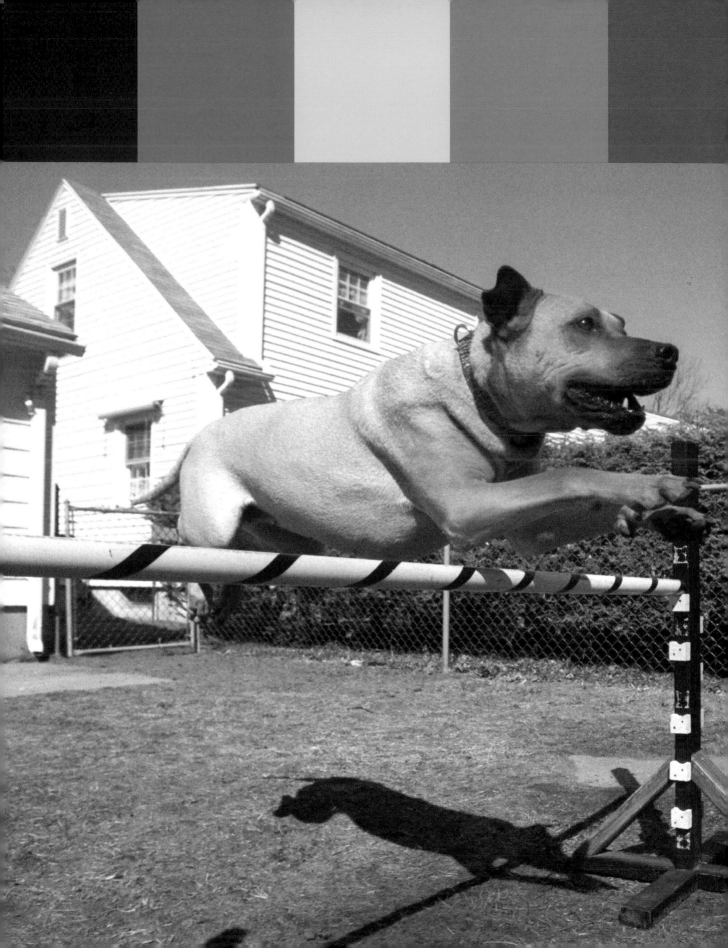

SEE SPOT RUN
Action

6

Great action shots of your dog can be some of your most exciting pictures, but they can be very hard to take. This is definitely a specialty in which high-end equipment will help you succeed. But even with just a point-and-shoot camera you can achieve good results.

Increase Your ISO

Most point-and-shoot cameras have poor minimum apertures and slow maximum shutter speeds when compared with SLR cameras. So, if you're using a point-and-shoot model, you'll need more light to achieve action-stopping pictures. That, in turn, means you need to use a faster films or higher equivalent ISO, such as ISO 800 to 1600 (or higher). Note that the faster ISO results in reduced overall image quality (i.e., increasing graininess, reduced contrast, muddy colors and details), however. For best action results, use high ISOs (high speed films) like ISO 400 and ISO 800, and pan.

Run, Spot, Run

Whether you want intentionally blurred images for artistic effect or you want the sharpest possible subject, always use the panning technique when photographing action. It helps your camera autofocus and reduces the blur of the main subject. To pan, track your dog in the viewfinder before, during, and after making the actual exposure.

With the panning technique, if you use a very fast shutter speed (1/1000 sec. or faster), you'll usually get a pretty sharp dog and background (right). If you use a slow shutter speed (1/30 sec.), panning will give you a relatively sharp dog and an extremely blurred background (bottom, left). In both images, the dog is sharp enough that you can still read the words on the vest. If your shutter speed is too slow (say, 1/8 sec.), the image will be too blurry with no details on your dog rendered sharply (bottom, right). (See pages 44 for more on shutter speed.)

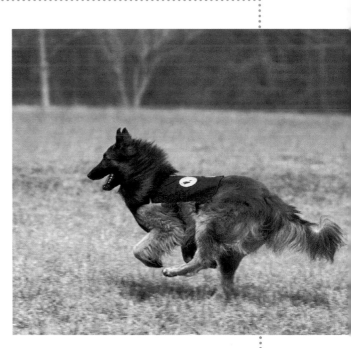

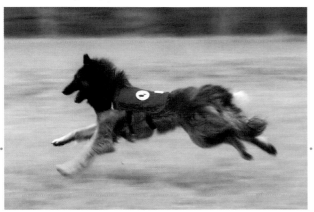

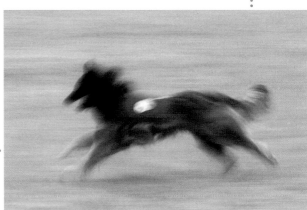

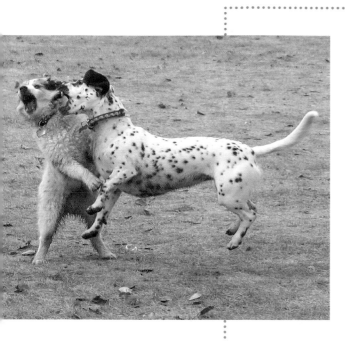

See Spot Stop

Action-stopping pictures of running, or otherwise moving, dogs require relatively fast shutter speeds. If you always use your camera in Program (P) or auto mode, the camera might not realize your subject is a fast-moving one; instead, it might expose for a relatively static subject, resulting in a hopeless blur. So, if your camera has an Action mode, choose that. Action mode predisposes the camera to pick fast shutter speeds that can freeze fast-moving action. On advanced cameras, you'd use Shutter Priority (S or T) mode and pick fast shutter speeds, such as 1/1000 sec. or 1/2000 sec.

And, since a lot of dog action occurs at a distance, zoom your lens to Tele (T) mode or switch to a telephoto lens (such as 200mm). This will magnify the scene like binoculars, but watch out: You need even faster shutter speeds to freeze the action with a long focal length, so always pan to be safe.

Wide Action

Sometimes, you'll be able to get up close to the action, and you can shoot it with a wide-angle lens. This yields very exciting pictures, because of your proximity to the subject—it will seem like you are in the midst of the fray. There's also the added advantage of not needing quite as fast a shutter speed as with a telephoto lens. Even so, be aware that elements and action that are closer to the camera will be more magnified in the viewfinder, so they'll blur more and be harder for your camera to focus on. You may want to use the prefocusing technique described on the following pages.

I think we are drawn to dogs because they are
the uninhibited creatures we might be
if we weren't certain we knew better.

—George Bird Evans

Prefocus

Most point-and-shoot cameras and some SLR cameras have a lot of trouble autofocusing on fast-moving subjects, especially if those subjects are coming straight at the camera, moving extremely fast, filling the frame, or a combination all three. You'll either end up with misfocused images, or there will be such a long delay between pressing the shutter button and the actual picture-taking that you'll miss the height of the action.

If your camera has manual focusing, you may want to try it. If not, try to predict where the action will be (such as at the top of a jump in an agility course), and lock the focus on that spot. As mentioned previously, you do this by holding the shutter halfway down. Wait with the shutter depressed halfway (and the camera ready to go) until the subject arrives. Then, finish pushing the button all the way down and complete the exposure. On SLR cameras with manual focusing capability, switch the lens to manual mode, and focus on the spot you want. Then just wait and click at the height of the action. It's sometimes easier to prefocus and let a dog come to you or to lead or coax a dog toward a predetermined spot. Having an assistant throw a ball over your head works well.

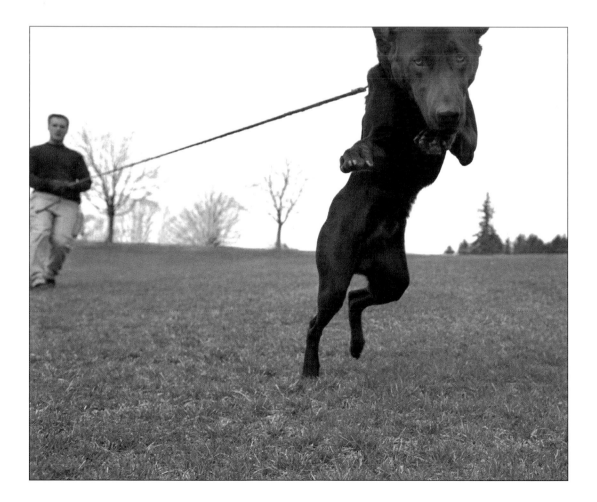

When photographing a fast-moving subject, it's sometimes easier to prefocus and let the subject come to you. In the case of an agility course, you know where the dogs will be jumping (left). Otherwise, dogs can be led or coaxed toward a predetermined spot (opposite).

If you get to thinking you're a person of some influence, try ordering somebody else's dog around.

— WILL ROGERS

PRACTICE

•••••••••••••••••••••••••••••••

Once you understand the basic concepts of action photography, you'll need to do a lot of practicing. If you shoot film, keep careful notes of your techniques, including shutter speed and aperture settings. When you view your pictures, compare the notes with your results to learn what worked and what didn't.

Most digital cameras offer nearly instantaneous feedback via a monitor. But don't get sloppy. Stop for a few moments and think about what worked and what didn't in each picture. It's the best way to learn.

There's only one way to get consistently good action photographs and that's to practice. Luckily, Pyper and Sade battle over coffee can lids and Frisbees often enough that there are plenty of chances to practice!

Crop the Action

Sometimes, even with a point-and-shoot zoom camera, you may be too far away from your dog to create frame-filling photos. Perhaps you can't get close enough to the action because of an obstacle, because you can't cover the ground quickly enough, or because the range of your zoom lens is limited. This doesn't mean you should give up. It just means you might have to spend a little more time or money after the fact to enlarge the best parts of the picture through printing or cropping.

Improving Things with Cropping

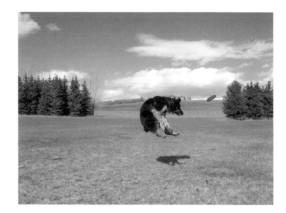

With cropping, you can not only get seemingly closer to your subject, but you can often improve your composition by eliminating unimportant or distracting foreground and background material. This also causes the subject to appear bigger in the final print.

However, cropping simply enlarges one portion of the image and "throws away" the rest. Therefore, for the best results when cropping, you want to start with the highest quality possible. This means shooting your film pictures on higher quality slow-speed films (such as ISO 100 or 200), or setting your digital camera to the highest resolution and quality settings, and a low equivalent ISO setting.

Remember, you have format choices when cropping. You can crop and maintain the same size ratio (such as 4 x 6 inches), or you can create a double-wide panoramic format. You can even turn a horizontal image into a vertical, and vice versa.

You can always crop an image later in your computer. Just make sure that you use film with the lowest ISO possible, or that you shoot at your digital camera's highest resolution setting (highest picture quality) for the best results after cropping.

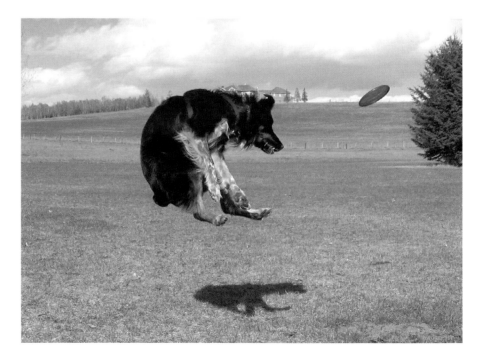

Cropping action not only lets you get closer to your subject, but often enables you to improve the composition by eliminating unimportant or distracting foreground and background material. This also results in the subject appearing bigger in the final image.

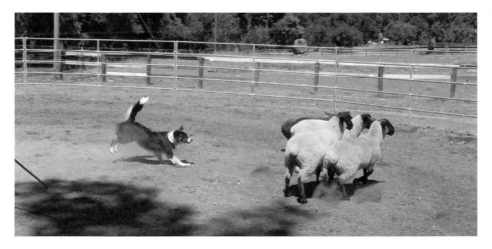

SIT, STAY
Posing & Portraits

7

Trying to pose your dog, or dogs, can sometimes feel overwhelming. Whether you're using basic obedience commands or securing your dog with a leash, an assistant just out of camera range can really help.

Leash vs. Command

The easiest way to get a dog into position for a portrait is to secure it with a leash or voice command. For dog photography, I like the lasso-type leash (the type the dog groomer or veterinarian uses). When the dog is relaxed and behaving, you can loosen this type of leash to the point that it falls low on the chest and is virtually invisible in a head-and-shoulders portrait, but you can instantly tighten it if control is needed. A loose leash is also easier to retouch out later, because it doesn't ruffle up the dog's hair or pull and distort the skin on the neck as much as a regular collar and leash.

The Joys of Dog Training

Well-trained dogs are a joy to shoot, because they will maintain a *sit-stay* or standing *halt* indefinitely. This gives you time to experiment with your camera position, lens setting, exposure, fill flash, and more. It also gives you the freedom to move a considerable distance away. And, you'll be able to play with posing. Try different angles from a straight-on full-body shot to a profile. Often, the nicest view is a three-quarter stand (the dog's body is pointed at a 45-degree angle to the camera). Once the dog is in this position, you can make a sound to get the dog to turn its head and make eye contact. Be careful not to call the dog's name or make the noise too appealing, or the dog will be tempted to break the command and come investigate.

For puppies and less-than-well-trained dogs, have an assistant use the step-on-the-leash method of enforcing a *down, stay*. You lure the dog into a *down* position with food, and then step on the leash so there isn't enough wriggle room for the dog to sit or stand. The dog may try to get up a few times, but when it sees it can't, it will settle down. That's when you start shooting. If you pick your angles carefully, you can avoid having your assistant's foot in the photo.

Stationing

Stationing is a technique of containing untrained, excitable, or fidgeting dogs in one spot long enough for you to take a great photograph. For puppies, stationing might be as simple as placing them in a box that's a little too tall for them to escape from. This also sets up a funny picture as the pups pop up like gophers to see out. For older dogs, you might want to get a little more creative. I like car windows or fences (see page 7). A car is the perfect containment device, because most dogs are comfortable in "their" cars and will boldly stick their head out a window because they feel safe. And, curious, friendly, and even more aggressive dogs will come to a fence's edge to greet you.

Dogs feel very strongly that they should always go with you in the car, in case the need should arise for them to bark violently at nothing right in your ear.

—Dave Barry

REMOVE THE COLLAR

● ●

This sounds simple, but removing an ugly or distracting dog collar can make a big difference in a portrait. Obviously, if you need the collar to control the dog or you're out in public with hazards around—or it's illegal in your area to have a dog off its leash—don't remove it! But when possible, the portrait will be prettier (especially with short-haired dogs) without it. You should at least remove reflective or brightly colored tags that can be distracting in the final image. You may be able to partially hide a collar under the fur on a long-haired dog, but you're out of luck with a short-haired dog.

A shiny metal collar is the only thing that detracts from the appeal of this image. Collars can sometimes be hidden under the fur of dogs with long coats, but even so, collars can cause some distortion of the coat that is difficult to retouch out. It's even more difficult to make a collar disappear through software magic on dogs with short coats. If it's legal and safe to do so (and that means safe for the dog, as well as safe for other dogs and humans present), remove the collar before shooting.

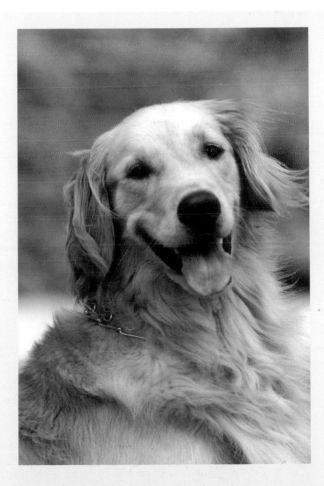

Eye Contact

The eyes of your dog are important in terms of composition. The old saying about the eyes being the window to the soul is a cliché because it is so true—eyes are expressive and unique, so they become the most important element in a portrait. Use the Rule of Thirds (see page 72) to place the eyes where they'll be most balanced from a compositional viewpoint.

Looking at the Lens

When your dog makes eye contact with you (i.e., the camera lens), the result is usually very compelling. The viewer of the picture feels an intimate connection with the animal. The eyes can be soft and friendly, or fierce and dominant—either way, the viewer is going to get a very vivid impression of the dog's personality.

Many dogs seem to view a camera lens as an eye and react in predictable dog behavior patterns. If the dog is dominant and fearless, it will probably stare right into the lens. With more submissive or fearful dogs, getting them to look into the lens will be more challenging. So, eye contact gives the viewer insights into a dog. You may need to have an assistant stand directly behind you and crinkle a treat bag or squeak a toy behind your head.

We even attribute human emotions to animals based on their eyes. Take soaking wet Pyper here, for example. When he looks off-camera, the picture is okay. But when he turns and faces the camera, we understand the inside joke and are sure he knows how to read.

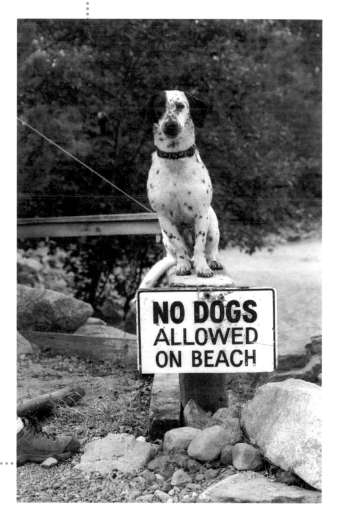

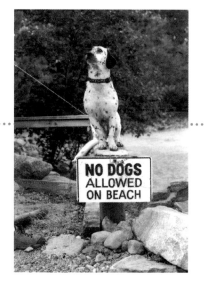

Looking Away

Not every portrait requires eye contact with the camera. Even in human photographic portraits, profile and three-quarter images in which the subject is looking off into the distance can be quite beautiful. Depending on the expression, they can evoke different moods. It's the same with dogs. Out of convenience, it is done more often because the dog's owner or an assistant can stand to either side and work to get the dog's attention. But it should also be done for artistic purposes. The short-nosed boxer, for example, is best represented in profile, when the dog's attention is directed to something that is at a 90-degree angle to the camera. A simple head turn produces a very different portrait (compare the two boxer images on page 112). Also, a slight upturn of the head can often result in a nice highlight in the eyes from the sunlight.

USE AN ASSISTANT

For control of the dog and for help directing its gaze, it's best to have an assistant nearby, preferably someone who knows and helps train the dog. If you want direct eye contact, this person should stand directly behind you to get the dogs attention. If you're squatting, your assistant should squat, because the goal is to have the dog look toward the lens, not above it.

In addition to attracting the dog's attention where you want it, an assistant can help reinforce a *stay* command at a close but still-out-of-camera-range position.

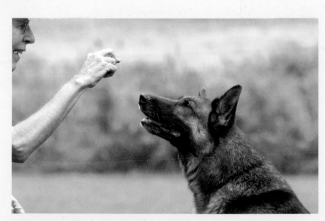

An assistant just out of camera range can help keep the dog's attention by presenting treats or reinforcing verbal commands.

Study your subject. If a dog has a particularly handsome or interesting profile, pose the dog accordingly, to its best advantage.

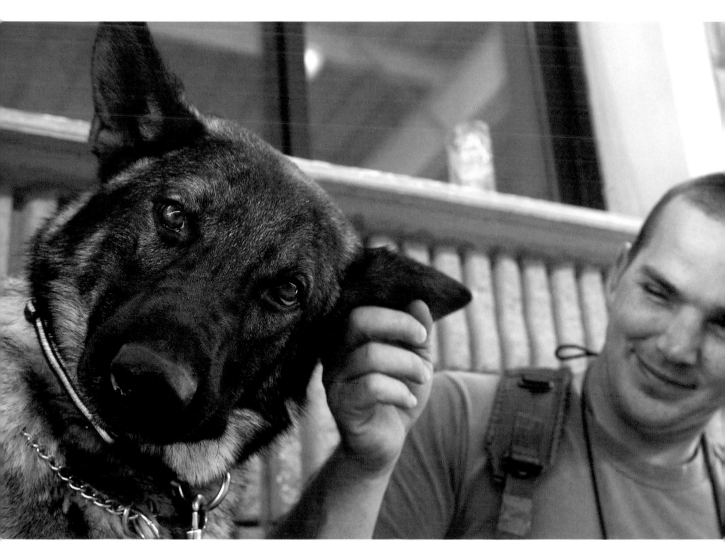

Multiple Subjects

If there are two (or more) subjects in your composition—specifically dog and human—you don't necessarily need both of them to look at the camera. A picture with the dog's owner (or handler, as in the lower image opposite) looking affectionately at his or her dog says volumes about their bond.

You can also, of course, try to get both to look at the camera, or to have them look or otherwise interact with each other. When your subjects are looking at each other, you can show their link in the photograph (both editorially and visually). Not only does this show off their bond and their love, but it will help unite your picture's composition. An image of a person and a dog looking away from each other reflects discord. The same is true with two dogs.

Interaction between two subjects can be physical, such as a hug or kiss, and it can also be visual, such as eye contact between dog and handler while waiting for the next command.

If you don't own a dog, at least one, there is not necessarily anything wrong with you, but there may be something wrong with your life.

—Roger Caras

Getting Good Expressions

Saying *cheese* is the old photo trick to elicit a smile in people. I call the dog version *show cheese*, because that's my German shorthaired pointer's favorite food in the world. To get a dog's rapt attention, let the dog know you have the best treats and rewards by giving it a sample for a simple task, like sitting. Dogs used to click-and-treat type training will behave better when the goodie bag comes out. And those unused to this training technique will certainly focus their attention on you (well, your treats at least!) when you start shooting.

Some dogs will react to any food presented, including the cheapest dog biscuits. Others are more finicky, so have a stock of yummy treats handy. Good choices include string cheese, hot dogs, dried lamb's lung, dried anchovies or squid (available at Asian food markets), meat baby foods, peanut butter, and just about any other smelly food treat you can come up with.

Dogs have great hearing and many are curious about new noises, or noises associated with food and play. Practice your cool sound effects. A short whistle, an imitation "meow" or bark, or weird squeaky noises usually work. On some dogs, these noises even elicit that adorable head tilt.

Having a tennis ball or favorite toy comes in handy. For some dogs, merely holding the toy is enough. For others, you can toss it in the air. With this method, you may lose direct eye contact (as the dog watches the ball instead of you), but you'll gain a perky-eared, alert expression.

Some dogs, especially hunting breeds, can be obsessed with critters. You can tap into their ancient wolf heritage by using bird calls or hunter's predator calls. The latter mimics the noise of a wounded rodent. Hunting stores sometimes sell bird's wings (or at least feathers) that can be attached to a string to tempt a bird dog into a point. And bottled quail and other game scents can be dabbed on toys like perfume to help get hunting breeds especially excited.

All the these methods should be used in moderation. If you give you dog too much stimulus, you might be pounced on! The cover image, for example, shows Gridley very excited and ready to spring into excited play—but he's still maintaining (barely) his *stay* command.

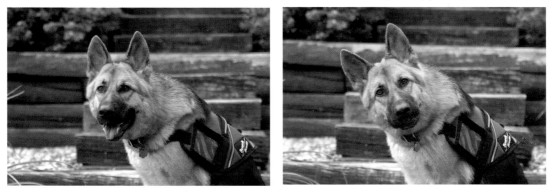

Treats and novel noises can inspire some dogs to smile or do that adorable head tilt. If you're photographing someone else's dog, ask the owner if the dog responds to certain noises or words, such as "Where's Kitty?" Most owners know exactly how to coax expressions out of their dogs.

A Note about Treats

Always ask a dog's owner if the dog has allergies or dietary restrictions before giving the dog a treat. And study up on foods that are poisonous to dogs, including chocolate, grapes, and raisins.

A duck call or predator call made for hunting is a great device for attracting the attention of dogs with a strong prey drive, because it mimics the sounds of animals they are apt to hunt. The one shown here quacks like a duck. Others make a shrieking sound like a small rodent in distress.

FAVORITE NOISEMAKERS

● ●

- ■ **Small squeaker toy** (I use one that's made for discreet show ring work and is only about three inches across, so I can hold it with my left thumb against the back of the camera.)

- ■ **Audubon birdcall** (This is a small red wooden birdcall. Twist the screw, and it makes a wonderful noise. It's a two-handed operation, so you'll need an assistant.)

- ■ **Balloons** (Remember pulling the neck of a balloon to let out a squealing blast of air when you were a kid? It may have annoyed your mother, but it grabs the attention of most dogs.)

- ■ **Duck and predator calls** (Your local outdoor store will sell these. Best yet, these calls usually have a string for hanging around your neck. And you can hold them in your mouth like a cigar, so you can keep both hands on the camera.)

- ■ **Pager** (Does your pager or cell phone have a test button? Try it and see if you get a reaction.)

- ■ **Crinkly wrappers** (Some dog biscuits and treats come in bags or wrappers that have a distinctive sound. Crinkle them and treat the dog before you start taking pictures. Then once you're shooting, a small crinkle should get the dog's attention.)

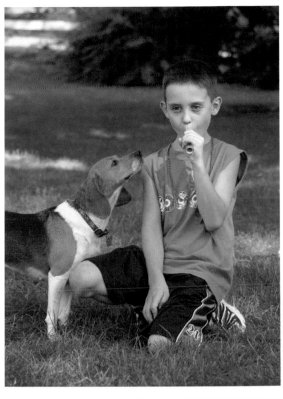

The bond with a true dog is as lasting as the ties of this earth will ever be.

—KONRAD LORENZ

Some dogs live for tennis balls. You can get the attention of dogs with strong prey drive by making sudden and erratic moves with a toy, or simply by having an assistant toss a ball up in the air.

Subtle Body Language: Ears

As a photographer, it's your job to look for the nuances of the dog's expression. Submissive (softly flattened) ears can be adorable, but if they go all the way to "worried," it can be unflattering. And perky, at-attention ears are the hallmark of a classic dog portrait.

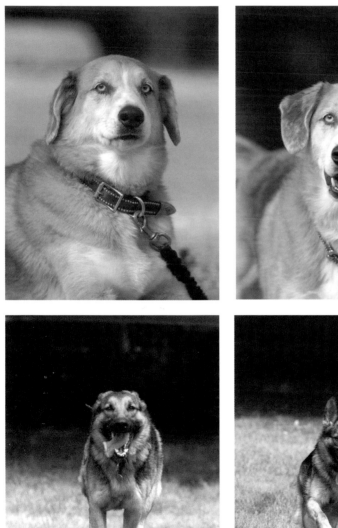

If you're photographing somebody else's dogs, they might be worried about your presence and your camera. This can result in an unflattering ear position (far left), especially when compared to the same dog with perky, alert ears (left). They might be so submissive, they refuse to look directly at you, which might be too dominant for them.

Dogs running on a *come* command may flatten their ears in a submissive manner. This is not as flattering as when the ears are perked up during play. Have someone throw a ball to get the dog to run, rather than using the *come* command to get the dog to run. Just this small change can make a big difference, so watch your dog's ears and consider changing tactics for initiating a running picture session.

The Tongue

The tongue also affects the picture. On hot days and during high excitement, most dogs will have their tongues hanging out. A little bit of tongue usually makes the dog look like it's "smiling." Huge, panting tongues just make the dog look hot. Bring your dog inside or into the shade to cool off—and keep a water dish on hand—if you want less tongue showing.

Some dogs are high-drive dogs, willing to keep playing despite the risk of heat stroke. As a responsible dog owner and photographer, it's your job to decide when a break is required.

Some photographers swear by peanut butter as a way to make dogs open and close their mouth, thereby pulling in their tongue as they try to smack it. I haven't had much luck, and usually end up with pictures of the dog licking its nose.

BE READY FROM START TO FINISH

Have your game plan ready before you get the dog or dogs ready. Plan a trip to the park or a gathering of dog friends. Watch the weather forecast. Dogs are often more playful after sudden temperature changes or the first snow of the season. If snow is in the forecast, I make sure my camera is ready. This means having batteries charged and a spare nearby. It also means making sure I've saved any previous images off my memory card and onto my computer and a CD or DVD so that my memory card has space. (Film photographers should keep a roll or two of different speed film with their cameras.) And, making sure my lens is clean of all nose prints!

In addition to keeping equipment ready, you should decide not only on your shooting location, but also on your camera settings in advance.

Also, some dogs get really excited at the beginning of any activity, so the first few seconds of the shooting session might be the best. The flip side of this is that they might be too excited at the beginning to listen to any *stay* command, or they may pull on the leash to investigate you. Have patience. Take some funny shots of the misbehaving beast and then wait the dog out. Eventually the dog will relax, allowing you to get tamer portraits.

Part of search-and-rescue dog training is teaching puppies that people can be found in the strangest places. In preparation for this, I waited, hidden in a snow cave, for young Ajax.

By the end of a shooting session, the novelty of the situation will have worn off, and dogs will get tired or bored and will settle down. Be ready for this, because you can get some good shots with mellower subjects.

Lenses for Portraits

The best way to take classic dog portraits is to photograph from a distance. Dog (and people) headshots usually look better if you step back and zoom in. The classic portraiture lens is in the 80mm to 135mm range, and even longer focal lengths like 200mm and 400mm can also look good. The reason is two-fold: The perspective is somewhat flattened for a flattering look. And, distant background will turn into a beautiful blur if the picture is shot in autoexposure mode, Portrait mode, or at a large aperture, such as f/2.8 or f/4.

Long Lens Tip

• • • • • • • • • • • • • •

Watch out! These long focal lengths increase the chance of blurry pictures from camera shake. They also reduce the relative depth of field, so you may need a narrower aperture to get the whole dog in focus. For the best results, use these lens settings on a bright day or with high ISOs (such as 400 or 800).

You can dramatically change how your dog looks by altering your camera position and lens selection. Looking down at your dog with a wide-angle lens produces a big-headed distorted version (left). This can be cute, but make certain that's the look you want. Using the same wide-angle lens and getting down to eye level reduces the distortion, but still gives the dog a big, bobble-head-toy look (above). It's not until you step away and swtich to a Telephoto (T) lens setting that you start to get a more natural, classical portrait (right).

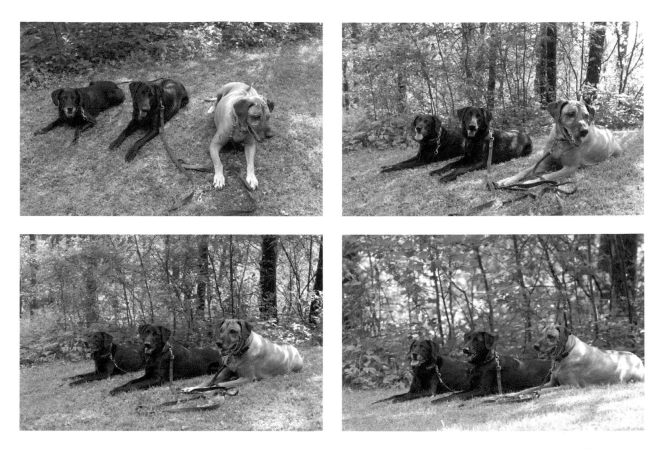

Even with groups of dogs, camera position and lens combination make a difference. In the two wide-angle versions (from a high angle, top left, and at eye level, top right), the closest dog looks huge compared to the more distant ones. Zooming the lens out to a midrange or moderate telephoto (bottom left) causes less distortion than the wide-angle, while the 200mm shows the least of all (bottom right).

Wide Portraits

Don't completely discount wide-angle lenses for portraiture, however. They have their uses. For example, when a family with a German shepherd moved to a new home, they used the left-hand image on page 26 on their change of address announcement, with the headline "Gunner's New Dog House." A wide-angle lens allowed them to get both the dog and the house in the picture.

Close-up, wide-angle portraits can have endearing distortions. The dog's face tends to look wide and oversized. So when goofy is good, put the lens to a wide setting and move in on the camera's minimum focusing distance. A wide angle lets you use optical distortion to surreally exaggerate an already exaggerated picture, such as Parker ready to roll in his go-kart (right).

Group portraits and portraits in a scenic setting are excellent situations in which to make a wide-angle portrait. A wide-angle lens can accommodate numerous dogs, while showing some of the surroundings, as well.

Dogs and Their People

If you're photographing people and their pets, you'll probably get a million throwaway photos of the person checking on the dog, futzing with position, or correcting behavior. Avoid this by coaching your human subject to ignore the dog and just look into the lens. Explain that it will be *your job* (as the photographer) to get the perfect pose from the dog and *their job* is to constantly look at the camera and smile. Then decide how close you want the them to be. For the most intimate portraits, try to position subjects with their heads close together. This will enable you to zoom in (or move closer) and fill more of the picture with faces rather than backgrounds. For the same reason, have the people sit or squat next to their large dogs or pick up small dogs.

Encourage human models to bring their head in close to their dog's head for frame-filling portraits. (If the human subjects are not the dog's owners, or aren't familiar to the dog, make sure the dog is friendly first before giving this direction.) With kids, it's easy because they love getting on the ground with their dogs.

Watch out for kids giving their dogs choke holds to keep them in place; even if it isn't hurting the dog, it just doesn't look good (near left).

A dab of peanut butter or lamb baby food on a person's cheek will invariably result in a big sloppy "doggie kiss." It works well for seated and standing subjects. And some dogs won't even need any food encouragement to become kissing fools!

DOGS & THEIR KIDS

● ●

Kids can be as antsy as puppies when it comes to a photo session. My advice is to roll along with their mood. Get cute, spontaneous shots as they give a hug to, or play peek-a-boo with, their dog. Eventually, start to coach them into your desired pose (top right and bottom left) and even keep shooting when they start getting bored (bottom, right). You can get some nice mellow images when things calm down. This entire series was the result of about three minutes of shooting time—which can seem like forever to a five- or six-year-old.

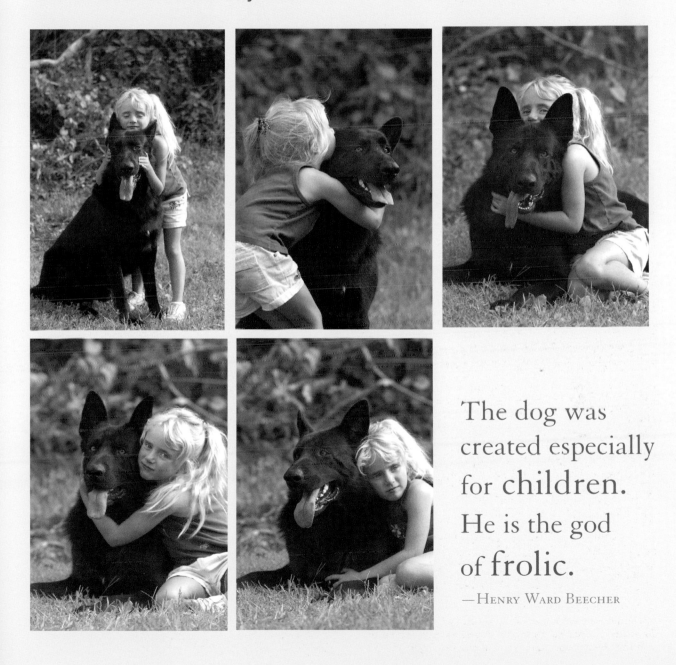

The dog was created especially for **children**. He is the god of **frolic**.

—HENRY WARD BEECHER

Pack Dynamics

As soon as you bring together a group of dogs, or dogs and people, posing becomes exponentially more difficult. Count on taking extra frames just to insure that the eyes of every dog and human in the picture are open on at least one shot. And with dogs, the group dynamics and potential territory adjustments can cause bad images.

My rule of thumb is, if you have six subjects (canines and humans included in the count), shoot at least six photographs. For a dozen, shoot a dozen photographs or more. Warn your subjects about what they're in for or they may start to break up the group formation after the first or second shot.

Next, try to orchestrate the pose. The natural instinct is to line everyone up in a row, but this usually doesn't make for a balanced composition, and the faces will be tiny if the group is a large one. Instead, try to layer the dogs and people into rows, with some tucked in front and others behind. Start with the people first, and place the largest in the back. Keep the more aggressive or territorial dogs out until everyone else is posed, and then place them in the outer positions

for a quick exit if necessary. If the dogs don't know one another or aren't compatible, be *very* careful. You may have to settle for an arrangement with some gaps between subjects to avoid a fight.

A multitiered surface like a staircase or picnic table works well for posing because you can have some subjects seated on the bench, some on the table, others standing behind or kneeling in front. This creates a composition with fewer gaps. More important, it condenses the group so that each face is larger in the final picture.

It's easy to get so caught up in positioning your subjects that you forget about the background. Before you start getting a large group into position check that you have a simple background with few distractions.

Lining multiple subjects up is usually the worst choice for portraiture. Not only is it boring, but it makes for a very loose composition. Instead, try stacking your subjects so that all the heads are on different levels. Using stairs to do this is a good choice for both dogs and people, because they place the subjects on different heights (see the image on page 51 for an example of this). Mixing up standing and sitting poses (or sitting and down positions) also helps. The top two images opposite show more successful groupings.

It's incredibly hard to gather a dozen or so people and dogs together and get a portrait in which everyone looks good. The real trick is to take a lot of pictures.

So they went their way, and the dog went after them.

— TOBIAS 11:4, *The Apocrypha*

Try to position a gapless group to avoid having one of the sitters look alienated from the rest.

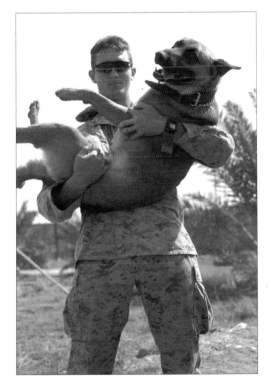

Having people pick up their dogs is a good way to minimize gaps between subjects. With small dogs, the size difference between dog and owner is a lot greater than with larger dogs, so it's especially hard to close the gap for a nice tight composition. It's easy for the human model to pick up a small dog. Of course, if you're a big tough Marine, you won't mind picking up a larger dog for the same effect—but for many, it's easier to kneel down next to big dogs.

Also, don't forget the over-the-shoulder shot for portraits of dog owners and their small dogs. This brings their faces quite close together.

DIGITAL DOGGIES
Computer Techniques

8

One of the most exciting new aspects of photography is the digital world—even if you're a film photographer! If you work in film, you can turn your prints and negatives into digital files. If you work with a digital camera, you're already there. Then you can alter and improve your digital pictures using photo-editing software. When you're satisfied with your photos, you can print them and even create a scrapbook.

Scanning

In order to create a digital version of a print, negative, or slide, it must be scanned into a digital format. Most people call this "digitizing" a picture. Instead of paper or film, you end up with a computer file, which you can save or erase (whether purposely or accidentally).

If you decide to scan your own pictures, you'll need to invest in one of the three types of scanners. A scanner capable of higher resolution scans will allow you to make bigger prints of the scanned pictures. Home users usually find a 1200 dpi flatbed scanner adequate for scanning 4 x 6-inch prints and making 8 x 10-inch or letter-size printouts of digital image files. Jumping up to 2400 dpi will cover your bases if you're starting with smaller prints, or plan on doing a lot of cropping of the original or going to bigger enlargements.

If you plan on doing a lot of scanning, consider a scanner that lets you place multiple small prints on the glass at the same time and then automatically senses the picture borders and scans them as separate files. This feature can be a great time saver.

If you only have a few items to scan, you may be better off having a mini-lab or camera store do it for you. You'll save the cost of purchasing the scanner and the time it takes to learn how to use it. Some mini-labs will also take a stack of your older prints and negatives and make a CD of these images. Many stores and malls now house digital picture kiosks where you can scan prints, do simple software improvements, and print files as traditional prints or as creative novelties like calendars or cards. A few kiosks will also burn a CD of the scanned images.

Most photofinishing labs now offer CD service for an added fee when you bring in your film for processing and printing. You get back prints *and a CD* with digital versions of all the images. Check the resolution—most are good for e-mailing and home inkjet prints, but aren't high enough resolution for professional applications. If you need super high resolution scans, you'll need to have each image scanned separately at a custom lab.

Print Scanners

Print scanners, or so-called flatbed scanners, are the easiest to use and least expensive type of scanners. You simply put your print or drawing face down on the scanner glass and activate the scanner. Many scanners are very inexpensive and most offer plug-and-play simplicity. You simply attach the scanner to your computer via a cord or wireless connection, install the software, and start scanning. Most give excellent results right out of the box.

Film Scanners

If you want professional-quality results, you'll want to step up to a film scanner. A negative or slide has more detail and contrast range than any print made from it. Prints also make third generation images (the film is the first generation, used to make the second generation print, used to make the third generation scan). So going closer to the source (the film) is the best.

Transparency or film scanners are designed to shine light through a piece of film to copy slides and negatives during the scanning process. Often they have film holders of different sizes to accommodate strips of negatives or mounted slides.

Some flatbed scanners also have film-scanning capability. But watch out: To scan film, you need a relatively higher resolution scanner, because most film is relatively small. For example, a 35mm film negative is only 1 x 1.5 inches in size, so it needs to be enlarged eight times or more to make an 8 x 10-inch print. Whereas if you scan an 8 x 10-inch print, it doesn't need to be enlarged because it's already at 100 percent of that size.

All-in-One Scanners

Stop into any office supply or computer store and you'll see amazing "do-everything" machines. These all-in-one units offer printing, scanning, photocopying, and more in one product. The savings in space on your desk and perhaps money (in comparison to buying everything separately) may be tempting. However, check the specs carefully. It may do all these things, but does it do each well? And do you need all the functions? You might be better off buying separate machines for each.

Resolution

Printer Resolution

By far, the hardest aspect of scanning—and digital photography, for that matter—is the issue of resolution. If your digital picture file has low resolution (is "low-res"), it will have a small file size. This is great for e-mailing images and opening them quickly on your computer. However, low-res pictures can't be enlarged very big without starting to look bad. High-resolution ("hi-res") pictures look wonderful when printed, even up to wall-sized posters. But they can have huge file sizes that eat up your computer memory and might choke your e-mail system. If you have an older, less powerful computer, it could crash and you'd need to start over. Adjust your scanner according to your ideal resolution. How big the scanner will make your digital picture is determined by a combination of the scanning resolution and enlargement percentage you choose.

On most scanners, you can control the resolution size of your digital scans. Usually, it's done through a combination of image size (referring to the original), dpi (dots per inch), and enlargement (doubling the area of the print equals 200 percent, for example). Set the dpi function according to how the file will be printed or viewed.

Picture Resolution

Picture resolution refers to the number of pixels that make up the image. This affects how large you can make your print before it starts breaking up and getting less clear. Technically, pixels per inch (ppi) is a measure of picture resolution, while dots-per-inch (dpi) is a measure of printer resolution. Unfortunately, most manufacturers and people use them interchangeably, so in modern lingo they've become indistinguishable. For digital photographers, ppi is the important term.

Picture resolution can be expressed in three ways: (1) In digital camera descriptions, you'll usually see picture resolution described in terms of megapixels (these are one-million-pixel increments). A total number, such as 2.16 megapixels, equals 2,160,000 pixels.

Or (2), megapixels can also be described as a mathematical expression that reflects the print ratio. It represents the number of pixels on the short side of the picture by the number of pixels on the long side, such as 1,200 x 1,800. And since 1,200 x 1,800 = 2,160,000, it's also 2.16 megapixels.

And (3), publishers and professionals will often describe picture resolution in terms of the output resolution. For example, publication in a book or magazine requires 300 dpi printer output resolution. That means every inch of the final output side must include 300 pixels. If the picture were to be printed in a book at 4 x 6 inches and 300 dpi output, then you would need a 2.16 megapixel image. That's because 300 (dpi) x 4 (inches) = 1,200 and 300 (dpi) x 6 (inches) = 1,800. As in option (2) in the previous paragraph, 1,200 x 1,800 = 2,160,000, which is also 2.16 megapixels.

It's important to note that much lower dpi output is needed for Internet applications or for good prints with inkjet and snapshot printers. To check how big your image is in most photo-editing programs, look for a command called Image Size or Resize. It will probably express the size in terms of options (1) or (2) as described in the previous paragraphs. This allows you to set the ppi (pixels per inch) of the image.

Photo-Editing

Today's photo-editing software programs are remarkably easy to use. Once you transfer a digital image to your computer, you can view it by using picture-viewing or picture-editing software. Most computer operating systems have a simple picture-viewing software included in the system. This lets you open and view the picture, and gives you a few very simple editing functions. However, to get the most out of your photographic experience, you'll want to invest in a true photo-editing software program. They allow you to improve, alter, and otherwise manipulate your digital pictures. Popular programs include Adobe Photoshop Elements, MGI PhotoSuite, Microsoft Picture It, Scansoft PhotoFactory, and Ulead PhotoImpact.

There's no doubt that photo-editing software can be daunting at first glance. But the basic functions are fairly easy to master. And the simple tips shown here and on the next few pages make up 95 percent of the changes or alterations I make in my photos.

Beginners mistakenly think of retouching as a way to fix a bad picture—and it certainly is. But it is also a way of improving an already great image. The real trick is deciding that a picture needs improvement. In the beginning, you may have to see the improved version to realize there was anything wrong with the original. The only way to develop this eye for retouching is to start playing with some of your pictures. After some practice, it will become second nature, and you'll send very few pictures to print without at least a few seconds of retouching. The following basic software functions will get you started.

An assortment of photo-editing software programs.

Cropping

Clutter and visual distraction are image killers. You should try to simplify your composition and eliminate bad backgrounds in-camera, but once the picture is taken, it's not too late to fix things. Cropping is one of the quickest ways to eliminate extraneous elements. You can also turn a horizontal picture into a vertical or use extreme cropping to create artistic renditions of ordinary subjects (see page 102).

It's important to note that when you crop an image, you are changing the picture's resolution, because you are, literally, eliminating pixels. This makes the newly cropped version a lower resolution than the original. Lower-resolution pictures cannot be successfully printed as large as their higher-resolution versions, so shoot at your digital camera's highest resolution whenever possible.

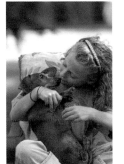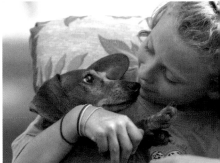

Auto Correction

Most photo-editing software programs offer an Auto Levels or Auto Enhance mode. As the name implies, with one click the software tries to fix the brightness, contrast, and color in an image. For example, rainy-day and snowy pictures usually come out bluish, and indoor shots often have a yellowish cast. The automatic control will usually fix this for you. This feature can also help improve the look of underexposed images. And, if the program has a Preview option, you'll be able to see the program's suggested changes before committing to them.

No automatic program is perfect for every picture. Automatic correction doesn't always improve the image, and it can sometimes make it much worse. I recommend trying it to see what it does. You can always select Undo if you don't think it's an improvement. Or, if it makes it a bit better, use it as a starting point and follow up with some other functions.

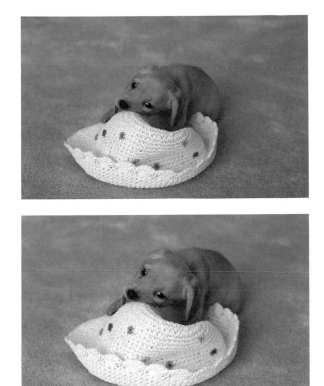

Brightness and Contrast

No camera takes perfect exposures every time, especially of light or dark colored dogs. In photo-editing software, you can quickly improve a picture by brightening or darkening it overall with the Brightness control. You can also increase or decrease the contrast. Increasing the overall contrast makes the shadows darker and the highlights lighter, and can sometimes help make a slightly blurred image look sharper. When the auto correction mode doesn't look good, you can try using the brightness and contrast controls individually.

| **Original** | **With Auto Levels** | **With Brightness** |

Dodge and Burn

The Brightness control affects the entire image, but sometimes you may just want to lighten or darken a small portion of an image. The Dodge and Burn tools allow you to selectively lighten or darken, respectively, a certain area of the image. For example, you can lighten the shadows on a sunlit portrait of your dog to let details of the coat show up. Or you can burn in a white tail to darken it. These tools are very customizable for the job at hand. Not only can you alter the size of your "brush," but you can change the strength of the dodging and burning. For the smoothest results, select a low level of opacity (such as 5 percent). It's better to make several corrections at 5 percent opacity than one strong one at 100 percent opacity.

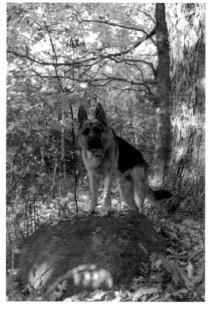
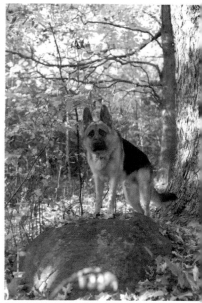

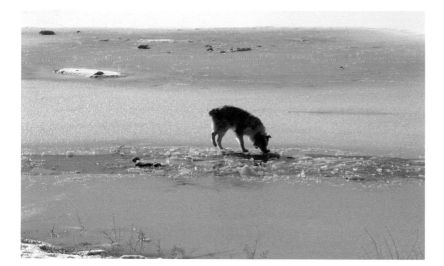

Color Correction

It's not uncommon for a photograph to have an unwanted color cast. This means the whole picture might look yellowish. You may not even realize it has a color cast until you see it side by side with a corrected or improved version. Adobe Photoshop Elements software offers a quick way to check by using the Variations command. First, it shows your original, then versions with more red, green, blue, cyan, yellow, and magenta, as well as lighter or darker versions. Click on the one you like best and you're ready to go. Other software programs have sliding bars you move to adjust the color.

You can also make extreme color corrections/changes with the same controls, such as turning a midday beach scene (above) into a sunset image (right). Similarly, a blue cast can produce a cold, moonlit feel.

Color Modes

Using the various color modes in photo-editing software, you can instantly change a color picture into a black-and-white, sepia (antique brown), or duotone image. Other options include Posterized, Cartoon, Saturated, and more. Some digital cameras let you do this while shooting. However, it's so easy in photo software that I prefer keeping my options open by shooting in color, knowing I change the color mode later. Note that what most people call a black-and-white photo is really made up of many shades of gray, not just black and white. Some software refers to this as grayscale.

Sometimes a color picture has dull or confusing colors. Other times it may be too literal of a rendition of the scene. In situations like these, consider converting to black and white, sepia, blue, or another color. Additionally, you can restore some of the richness of an old faded snapshot using a combination of color balance and contrast controls (right, bottom image).

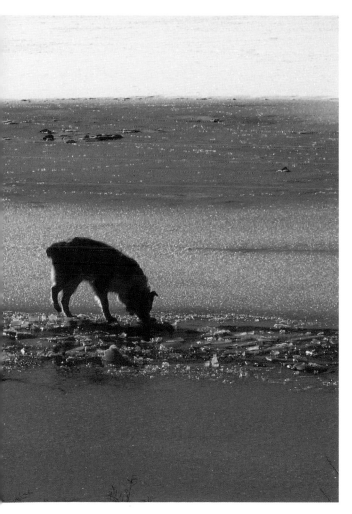

Noise Adjustment

Images photographed in dim lighting can look grainy, without smooth tones. With film images, this is caused by using high-speed films (such as ISO 800 or ISO 1600) or drastic underexposure. With digital images, it is the result of using a high equivalent ISO setting or underexposure. Noise reduction software, such as Noise Ninja, can help improve it. You'll lose some of the fine detail in your image when you apply the reduction. In some images it won't matter, in others it could ruin it, so always preview the change before committing it. Better software lets you make the correction at different levels for more controlled results.

Stamp or Clone Tool

The Rubber Stamp, Clone or similarly named tool is one of the quickest ways to retouch your pictures. The name *rubber stamp* is a good metaphor for how it works. You use one part of the picture (such as perfect grass) as an ink pad. You click and pick up the ink (this portion of the grass) and then stamp it down elsewhere in the picture. Use it, for example, to cover a bit of trash in a different part of the lawn. By similarly copying other tones, you can quickly clean up runny eyes or bloodhound slobber in a dog portrait, or cover a facial blemish on the people in your pictures. You can also eliminate distracting highlights or bright colors in the background. Random textured areas, such as grass or dog hair, are often the easiest to work with. Select a new sampling area ("ink") often to avoid creating an unwanted pattern.

Frames, Words, and Other Stuff

Frames and Templates

Most photo software comes with a few templates for fun frames. You simply add your picture inside a predesigned border, and you have a ready-to-print calendar, greeting card, or photo novelty.

Write On

Don't under estimate the power of words, both for their literal content and their graphic effect. You can add text to your pictures in most photo-editing software programs. Often, the command for adding text is the letter A or T in the toolbox. Click on it and type your text. It will appear in a text box that you can move around or resize. You can then adjust the font, as well as its size, color, and shade. Advanced programs let you stretch, shrink, and even curve it. You can even make it semitransparent.

When using text with your images, think about the color you choose for it. Dark letters are easier to read against light backgrounds, and vice versa. Contrasting colors (like yellow on bright blue) might be bold, but they can be hard to read. If you're having trouble reading the words against a busy background, you can lighten or darken the picture *behind* the text using the dodge or burn tools.

Plug-Ins & Specialty Software

There are several specialty photo software plug-ins and programs that give you extra capabilities. Plug-ins are additions to your current software that you buy or download for free. For example, AV Brothers offers a plug-in that produces a curled-edge effect. Kai SuperGoo is a liquid effects program. And noise reduction software, such as Noise Ninja, can be a plug-in or stand-alone software.

Programs that create "goo-ing" or liquid transformations of your pictures can produce some goofy effects.

Learn the *Save As* Command

Every photo software program has a Save As or similar command. Use it. And use it often! Especially in the beginning, you're going to make a lot of mistakes. By using Save As to save versions A, B, and C—and thereby retain your original file—you can always start over at an earlier version. Even powerful programs, like Adobe Photoshop, that save histories (records of each change you make enabling you to jump back to an earlier stage) can't always help you if the program freezes or the computer crashes.

I also use the Save As command to create versions of a picture at different resolutions. I save the highest resolution version under a descriptive name/date combination. For example, AJ-0806a may mean it's the first or best picture of Ajax taken in August 2006, while AJ-Run-01 could mean a shot of Ajax running. Whatever the system, it should be something you will recognize. I find it easier than the default number assigned by the camera. That being said, I have many friends who prefer the default setting, such as DCS-6278, because then all their pictures stay in chronological order—at least until the camera's numbering reaches the maximum and starts over.

Note that some cameras restart their numbering at 001 when a new memory card or stick is started. This is dangerous, because when downloading them to your computer, you can accidentally overwrite your previous 001 image. Check your camera instruction manual. This is usually a feature that can be changed to continuous numbering through the menu selection.

If I plan to use the image for e-mail or on my Web site, I then save a version that is much smaller in resolution. I like my e-mail pictures to be about 4 x 6 inches at 100 dpi (400 x 600 pixels), saved as a JPEG file format at fairly high compression. Why? Because this creates a small file that's easy to send and receive. However, it's far too small for printing. I usually add a "W" or "WEB" to the end of the file name (before the ".jpg"). I might even have a third version for small prints, in the 1,200 x 1,800-pixel range (about 4 x 6 inches at 300 dpi), which I use when I upload pictures to an online vendor like www.shutterfly.com or www.kodakgalleries.com.

Albuming Software

Whether you shoot with a digital camera, or scan your prints, you'll probably want to get some sort of albuming software. This is a computer program that helps you keep track of your images. Better software enables you to track not only the images on your computer, but images you've already archived to CD or DVD. Most albuming software lets you sort your photos into folders of *albums*. Inside these albums, you can view by file name, date modified, size, or most useful, thumbnail picture (small 1-inch versions).

The best albuming software allows you to assign keywords to each picture file, creating a searchable database, regardless of where the picture is stored. It only works, of course, if you take the time to select keywords, such as *Rover* or *puppy* or *agility* or all three. This is handy if, for example, you want to create a scrapbook of Rover from the day you got him as a puppy until now. Typing in the keyword "Rover" would yield the images with this keyword.

Most photo-editing software programs include some sort of albuming function. You can also get free Kodak EasyShare software from www.kodak.com. This software combines albuming with a few retouching functions, and also streamlines the printing process. Not surprisingly, it automatically links up with Kodak Galleries, an online printing store, too.

Adobe's powerful Photoshop Album has a free starter edition, available at www.adobe.com. A nice function of this software is an option that lets you search for photos based on how you've used them. You could find all the pictures you've e-mailed to your parents in the past year, for example. If you're into collaging (manually or in the computer) or want to decorate a room with a particular color theme, this software can even pull up photos that have similar color characteristics for a collage or art project. The free starter edition of Photoshop Album is not as powerful as the full version (which you have to buy), but it has most of the functions you need.

ADVANCED FUNCTIONS

● ● ● ● ● ● ● ● ● ● ● ● ● ● ● ● ● ● ● ●

Beyond the basics described, you may want to get some help. There are many excellent books and DVDs on photo-editing software, and seminars and classes are available in almost every city. I've been using Photoshop for years, and still discover new and advanced functions. Each new version gets better and better.

Scrapbooking

Scrapbooking is much more about the graphic and content decisions than how the pages are actually put together. In the old days, scrapbooking and albuming meant creating a photo album by slipping pictures into albums that had photo pages or gluing them into scrapbooks. Many people still make traditional scrapbooks in this manner. However, there are now two new options available: digitally printed scrapbooks and digital scrapbooks.

Digital Options

Digitally printed scrapbooks involve designing scrapbook pages on your computer, adding type graphics and photos to make a single page, and then printing it out. The result is a single print with multiple photos, but no need for glue, tape, or photo corners. Purely digital scrapbooks utilize the same design concept but are designed to be viewed on your computer or TV. You can share them on CD or DVD, or send them to friends and family via e-mail. Software allows the addition of music or your own voice and a wide variety of graphic designs, including a 3-D style album in which the pages turn virtually.

Archival Concerns

Since scrapbooks are designed to become family heirlooms, make sure every aspect of them is archival. The scrapbook paper should be acid-free or marked "archival." Glues and tapes should also be archival because cheaper tapes and some glues can quickly cause discoloration of the photos or papers. If you're making the prints at home, make sure you invest in an archival printer, inks, and printing papers, because regular inkjet prints will fade quickly. You can also upload your pictures to an online photofinisher to get conventional photographic prints.

Resources

Due to the popularity of scrapbooking, there are now many stores, magazines, and books dedicated to the subject. If you are craft oriented, you can come up with some wonderful designs that combine photos, memorabilia, and color elements made from paper, cloth, cutouts, and more. You can also purchase premade origami, stickers, and trinkets designed to be pasted into scrapbook pages. If you don't have a store dedicated to scrapbooking, visit your local art supply or crafts store. Even the fabric store will have trim and ribbons you can use. The limits are just your imagination.

Designing Pages

Think about the design of the pages in your favorite magazine. Usually, there's a mixture of small and large photos, text and other design elements on every two-page spread. Occasionally, there will even be a spread of just one particularly spectacular image.

For a scrapbook page documenting Sousa's muddy antics, I first chose a background color that echoed the mud (opposite, top). I took what I considered the strongest photo and enlarged it to fit most of the left-hand page of the spread. I also cropped it from a horizontal photo into a square to fit. I included a vertical image on the facing page for variety. I also added text and paw prints over some of the pictures. Then, I changed the background on the right-hand page to a color that tied in to the dog's coat (opposite, bottom). The possibilities are endless.

You may be surprised to learn that I made these "pages" on the computer as a single "photo" and then printed them out on single sheets of paper. They could just have easily been made with actual photographic prints, colored paper, scissors, and glue. How your "pages" are "manufactured" is far less important than how they are *designed*.

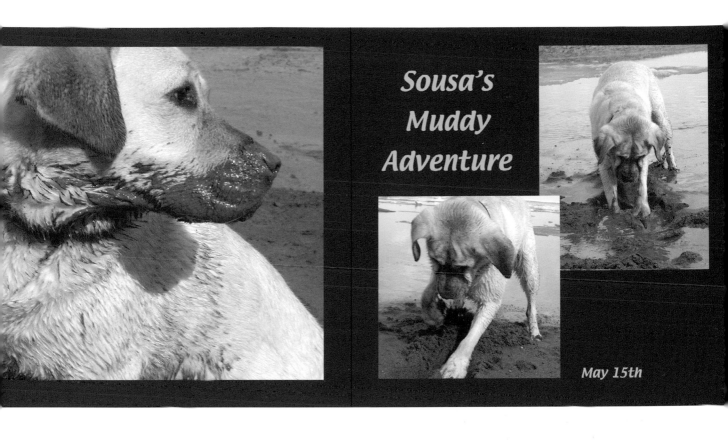

Sousa's Muddy Adventure

May 15th

Sousa's Muddy Adventure

Scrapbook Themes

Books are organized into chapters and sections that present topics in an orderly fashion. Related topics are usually grouped together, often on the same spread, and graphic elements run throughout the book. It's no surprise that a scrapbook that has some organization or themes is easier and more fun to view. Most scrapbooks and photo albums are put together chronologically. And that makes sense. If you want to go back and look at pictures of Pyper as a puppy, you might pull down the 2002 album. However, it can be a lot of fun to add some special pages that are designed thematically. The following topics are a good starting point. Browse through your images and see if they fall into other natural categories.

My How We've Grown

Consider making a page that shows the progression as your dog grows up. If you plan ahead, you can use an object of known size for comparison, such as a door or a dog bed. Adult dogs are a good size comparison, as well, because the puppy changes in relation to them.

A **door** is what a dog is perpetually on the **wrong** side of.

—Ogden Nash

Repetitive Themes

Repetitive themes are a good idea for any photo album or scrapbook. Holiday images are an easy way to do this. A red Santa cap or other holiday accessory is an easy gimmick. You can also tie images together with other elements you include on your scrapbook pages, such as an orange-and-black background (with bats or witch clip art, of course) for Halloween holiday dress up images.

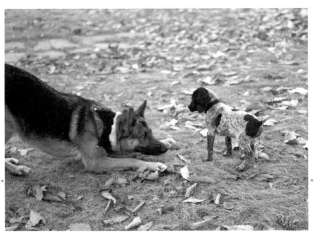

Training

Don't forget those training memories. Teaching *sit* or *leave it!* commands might be agonizing when you're in the midst of it, but quite funny when you look back on it. Bring your camera to puppy obedience and other dog classes.

Funny Bones

Humorous shots are hard to take. First, you have to see it happening, and recognize the humor or irony in the situation, and then you have to be ready to snap the picture. Sometimes, you can set up the picture. In the shot of Yukon checking the shark to see if anyone has been eaten (near right), we were able to set up the situation; she is trained to *check* where I ask, so with a simple command she did just that. In the other example (far right), Ajax was not smelling the flowers but actually hunting the bees attracted by them.

Costumes are an easy way to take funny pictures. Either the costume itself can be amusing, or the dog's expression can make the picture (right). Not all dogs like to wear clothing, especially on their heads. Use the conditioning training methods described in appendix A to help associate the experience with biscuits or treats.

Trouble

Catching your dog in the midst of doing something playfully "disobedient," such as mucking around in the dirt might make for some of your best images. The joyful reckless abandon with which your dogs destroy your yard or sofa are all part of living with dogs. You may not be happy when your dog digs a hole in the backyard, but in hindsight, these pictures make great additions to your scrapbook!

Slice of Life

Don't forget the daily antics. Friendly greetings between your dogs, frolicking in the snow, rolling in the grass, napping in the back seat of the car, or a special ice cream treat are important rituals that make up the rich story of your life with dogs.

A FEW MORE IDEAS

The Pack

Don't forget to document the pack. It's a great idea to have a portrait made of you and your dogs at a specific time of year, each and every year. You can visit a professional portrait photographer, recruit a photo-savvy friend, or use a tripod and take self-portraits. People change a lot, in terms of hairstyle, fashion trends, and normal aging— and dogs do to! Looking back on an annual basis is a lot of fun. Once you've done it for a few years, you can show the current picture as a full page on the right in a scrapbook and a compilation of the other years (in chronological order) smaller on the left.

I Was There

Traveling with a dog is becoming more common as more and more hotels, motels, and campgrounds allow well-behaved pets. Instead of sending home boring store-bought postcards, try sending your own we-were-here pictures. You'll either need to use a tripod, or ask a traveling companion or stranger to snap the picture. If you're using film, get it processed and printed at a one-hour lab, and then attach an adhesive postcard back or insert the picture into a greeting card with a slot for attaching your photo. Digital photographers can find a photo kiosk at grocery stores or malls. Simply put your memory card or stick in the slot, follow the on-screen menu to integrate your picture into a postcard or greeting card, and select print. Minutes later you have a ready-to-mail postcard. Make an extra copy for inclusion in your scrapbook, too.

Appendix A: Fearful Fido

Just like some people, certain dogs have learned to be camera shy. Perhaps they were scared by a camera flash when they were young or they had a bad experience with a photographer or they just don't like that scary thing in your hand.

My dogs couldn't care less about whether I'm shooting pictures or not. But whenever I see something cute and get up to get my camera, they stop the cute antic to see what *I'm doing*. I've learned to try to predict perfect picture moments and have my camera ready. If the moment is not predicable, try to be very nonchalant when you get up to get your camera, so as not to pique their interest and distract them. That being said, I have yet to get the perfect picture of my dog Ajax sleeping on his back with all four legs in the air, and I've been trying for five years.

If your dog is truly fearful, however, you'll need to use counter-conditioning. This is a training technique used by animal behavorists to help fearful dogs overcome their anxieties. Basically, the goal is to have the dog begin to associate photography with rewards and good times, rather than anxiety and fear. You start with a very small dose of the fear-causing stimulus and give high-value treats—use just so much stimulus that the dog is a little uncomfortable but still willing to take the treat. Over several training sessions, the object of horror comes closer and closer, but never so close as to cause a full-blown fear reaction. Ideally, the only time the dog gets these high-value treats is in the presence of the stimulus that causes the fear. Eventually, the dog begins associating the treats with the stimulus, so anticipation of the treat replaces the former fear reaction.

For example, Breezy, a big goofy German shepherd, was terrified of the camera flash. She was also terrified of thunderstorms, so her owner assumed she thought it was lightning. The cure for Breezy was counter-conditioning. In this case, it required two people. To start, a big fuss was made over a new treat—lamb baby food. In the first training, Breezy was asked to sit in the kitchen and given tiny licks of the baby food, and fussed over with priase. In the second session, the same thing was done, but the assistant walked into the next room, partially closed the door and took a picture of the wall with the flash. Breezy was a little startled by the distant flash, but not so scared as to leave her post and abandon the treat. Subsequent training over several days brought the flash closer and closer, until the assistant

was able to shoot a close-up shot of the dog with flash. This training might not have worked if the fearful stimulus was too strong at first (flash in the same room, for example). But because it gradually got stronger, and the dog was innoculated slowly, it worked as the fearful flash/lightning association was gradually replaced by a happy flash/treat association. Now when she sees the camera, Breezy expects (and gets!) a treat.

In another example, Zack, a rescued terrier, took longer to train. He used to run and hide behind the couch whenever his owner even opened the drawer where the camera was stored. Since the owner got Zack at the age of two and he was already scared of the camera, she didn't know what caused it. I suggested she start storing his favorite biscuits in that drawer. At first she'd just take out the biscuits from that drawer, and not the camera. Once Zack learned that the drawer meant good things, his owner could nonchalantly pull out the camera and place it on the counter in the process of getting the biscuit. Once that got no reaction, she could keep it in her right hand while she fed a biscuit with her left. And on and on until finally she could hold the camera to her eye, pointed at Zack, while feeding him a biscuit. It took a lot of work, but today, Zack starts dancing with joy when he sees the camera, because he knows it means biscuits will be in abundance.

Wary Subjects

If you don't have time to counter-condition a camera shy or camera fearful dog, or the counter-conditioning was unsuccessful, you'll need to resort to taking candids with a long focal length lens. If you have a zoom point-and-shoot camera, set it to the Tele (T) setting and step away from the dog. With an SLR camera, switch to a telephoto lens, such as one in the 100mm to 300mm range. Then shoot pictures from a distance. Candids are tough to shoot. The long lens adds technical problems. And the inherent subject action and photographer's need for stealth make composition more difficult. For success, plan on shooting a lot of images, and simply throw out (or delete) the bad ones.

You'll have the best luck if the dog is engaged in an activity it loves—investigating new smells in the garden, or playing with a favorite person or other dog. And then of course, there are the adorable sleeping-on-the-couch shots.

Appendix B: Meet the Dogs

I'd like to thank my many dog "models." Many of them are working dogs, who search for lost and missing people or work alongside our soldiers. Others are beloved pets, whose talents range from agility and obedience championships to King of the Couch. Here are some of them:

Ajax & Yukon: You'll see a lot of photos of my two dogs throughout this book because they are always nearby and are very willing subjects. Ajax, a black-and-white German short-haired pointer, is a search-and-rescue dog trained in both trailing/tracking and human-remains detection. Yukon, a retired search dog, originally came to me after she flunked out of guide dog school.

BB: Found after being shot with a BB gun and left for dead, she was adopted by Carol Lussky and is the unofficial mascot for ILL-WIS SAR Dogs.

B.O.W.A.: With a name that is an acronym for the Best of What's Around, BOWA was rescued by the Leech family along with Great Dane Libby.

Comanche: A German shepherd search dog handled by National Parks Service Ranger Janet Wilts, Grand Teton National Park.

Comet: A small black Chihuahua with a very appropriate name. His owner (shown with him on page 123) is Hailey, so he is Hailey's Comet.

Customs dog: This US Customs dog walks a conveyor belt while checking packages for contraband at the ATF Training Center in Virginia.

Daisy May: A bloodhound search-and-rescue dog trained by Lew Fletcher, Daisy May is now retired from TASK-9 in Connecticut.

Dan: Handsome Dan is a US Marine Corps military working dog specializing in explosives and drug detection work.

Fine: Fine von der Madlage is a Deutsch Kurzhaar-German shorthaired pointer owned by Dr. Gayla Salvati, DVM, Red Earth Kennels, Oklahoma.

Gemma: Handled by Leading Aircraftsman Andrew Hobby, Royal Australian AF, 383rd Expeditionary Combat Support Squadron.

Godfried: The wolves shown in this book were photographed at the Wildlife Science Center in Forest Lake, Minnesota.

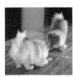

Gordon: This little rascal is a Pomeranian puppy owned by fashion photographer Eric Bean and lives in New York City.

Gridley: Our cover boy is owned by Meleda and John Lowry. He is the fastest dog I know at the five-yard dash—but only if there is food at the end!

Gunner: Ch. True Gem's Shot Thru the Heart, bred by Cheryl Zaic, True Gem Chinese Shar Pei Kennels in St. Croix Falls, Wisconsin.

Gunner: Born at the Fidelco Guide Dog Foundation and now owned by Meleda and John Lowry, Gunner is a half brother to my dog Yukon.

Harley & Ditto: Two Pembroke Welsh corgis owned by Sue Bentley, they are champions at looking cute for the camera!

Hero: USAF Staff Sgt. Chad Reemtsna spends quality time with Hero while waiting for vehicles to search at Kadena Air Base in Japan.

ILL-WIS SAR dogs: Many of my canine models are active or retired working dogs from my volunteer search-and-rescue unit, Illinois-Wisconsin SAR DOGS. They are (top row, left to right: in the first three pictures, German shepherds Vixen, Trucker, Sasha, Beck, and Bullet (Janet Anagnos and Dennis Schenk, owners); Labrador mix Ty, Labrador Sage, and Rhodesian ridgeback Cayce (all rescued by Bob and Sharon Naskrent); border collie Wrigley (Carol Davis, owner); Malinois Xander (Sue Christensen, owner); Labrador Buster (Bryan Ryndak, owner). Bottom row: redbone coonhound Doc (rescued by Geri Messina); bloodhound Mika (rescued by Geri Messina); boxer Brando (Marie Ciavarella, owner); bloodhound Josie Wales (Patti Gibson, owner); mixed breed Buddy (rescued by Carol Lussky); German shepherd Grace (rescued by Kara Spierling); bloodhound Dixie (Vicki Pulver, owner)

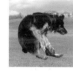

Killian: One of several bloodhounds bred by Shuler Kennels, and raised and trained by Jack Shuler in Salem, Illinois.

Kwinto: USMC Sgt. Ken Porras of the 24th Marine Expeditionary Unit works with military working dog Kwinto to detect explosives.

Libby: A young Great Dane cross rescued by the Leech family, she towers over her three roommates—two Chihuahuas and a dachshund mix!

Lynx: This talented black-and-tan Frisbee catcher was rescued from That'll Do Border Collie Rescue in Vancouver, Canada.

Mac: A German shepherd owned by Peggy Callahan, Mac spends much of his time guarding the Wildlife Science Center in Forest Lake, Minnesota.

Mack: USAF Senior Airman Gregory Darby shares a moment with his military working dog at Kunsan Air Base, Republic of Korea.

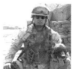

Matthew: Cahill's Matthew Dillon is a deaf German short-haired pointer rescued by Patty Rusch. He excels at both napping and agility.

Max: A Pomeranian who is not too keen on baths. He is owned by fashion photographer Eric Bean and lives in New York City.

Moe: An English shepherd search dog trained by Heather Houlahan and Ken Chiacchia of Allegheny Mountain Rescue Group.

Mudpie: Miss Madison Blue Belle is a search dog handled by Paula Chambers, Alpha Team K9 SAR. She aided in Katrina recovery efforts.

Oscar: Mitsi Webber and her FEMA certified Labrador retriever worked the World Trade Center recovery with Florida Task Force One.

Parker: Parker is the sweetest Weimaraner dog. He was adopted as a mature dog by the Marlin family in Boardman, Ohio.

Pearl: A French bulldog with a ton of character, she lives in Brooklyn, New York, with Ellen Labenski and Ted Houghton.

Pip: This English shepherd is a search dog, as well as a talented sheep herder! He is handled by Heather Houlahan and Ken Chiacchia.

Rex: USAF Staff Sgt. John Smithhart (363rd Expeditionary Security Forces Squadron, Saudi Arabia) and Rex check for explosives.

Rex: USMC Lance Cpl. Marshall S. Spring hoists his Belgian Malinois military working dog at Twenty-Nine Palms Base in California.

Reikie: A military working dog, here with Cpl. Per Larsen from the Norwegian Mechanized Battalion, Kongsberg, Norway.

Riley: A golden retriever handled by Chris Selfridge for PA Task Force-1.

Rin Tin: USAF military working dog Rin Tin is assigned to the 354th Security Forces Squadron at Eielson Air Force Base in Alaska.

Riven: J. F. Coventry's Return to Rivendell is a fly-ball athlete owned by Shauna Jannett.

Roxi: A German shepherd owned by Pete Ralph. At the time of this photo, she was in training as a search dog with MINN-SARDA.

Rukker: A Belgian Tervuren trained in human-remains detection. At the time of this photo, he was handled by Lisa Mayhew.

Sam: This well-fed English setter lives in Germany, where many restaurants (and ice cream parlors) allow well-behaved dogs.

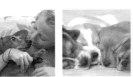

Sibravo pack: The Sibravo family has rescued, fostered, adopted, and re-homed over a hundred dogs, including many of the puppies on pages 94–96.

Smacky: A shih tzu mix owned by the Turner family in Chicago, he isn't a big fan of photography and couldn't wait for the session to end!

Soleil: This Doberman (right) is a search dog with Texas Response Unit SAR. Her fennec fox companion (left) is named Meika.

Sousa: A champion mud-digger, Sousa is also a search dog handled by Greg Friese on K9 emergency response teams.

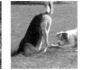

Spencer: Debby Alexander bonds with her German shepherd. At the time of this photo, he was in training as a search-and-rescue dog.

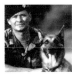

Sugar: A Lab mix rescued by Megan Tully, Sugar's friends include three dogs, a herd of sheep, and a pig named Rosie.

Thornton pack: Zealous Tally Ho, Shasta, Oakley, and Aero are owned by Nancy Thornton. Dalmatian mix Pyper, owned by Susan Lodge, also runs with this pack.

Wan-to: USAF Staff Sgt. Louie Borja and this military working dog are a drug detection team that searches for drugs headed to the US.

Whisky: Whisky vom Bieberstein is a Deutsch Kurzhaar who worked as a Perry Oklahoma Police Department narcotics dog with handler Mark Combes.

Willie: Boxer Willie did not enjoy this training session, in which he learned the *leave it* command. He wishes he lived in Germany (see Sam's listing).

Zaic puppies: This and the other shar pei pups in this book were bred by Cheryl Zaic, True Gem Chinese Shar Pei Kennels, Wisconsin.

Index